LEARN TO DRAW

FAMILY GUY™

Walter Foster

AS SEEN ON TV

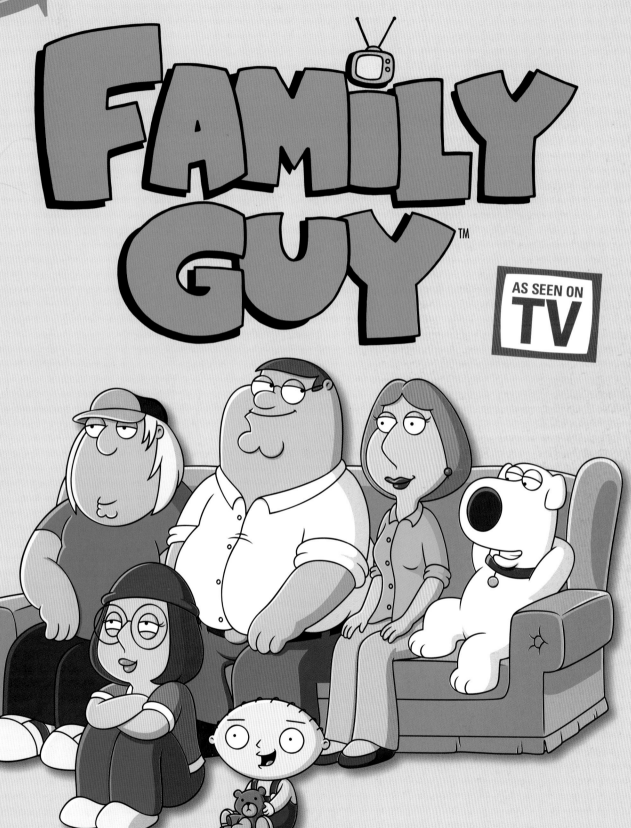

Text on pages 90, 96-97, 102, 106, and 124 written by Anne Landa
Text on pages 4, 82, 86, and back cover written by Jennifer Gaudet

www.walterfoster.com
3 Wrigley, Suite A
Irvine, CA 92618

1 3 5 7 9 10 8 6 4 2

TABLE OF CONTENTS

FREAKIN' SWEET!

HOW TO USE THIS BOOK

In this book you'll learn how to draw the Griffin family and several of their friends with step-by-step instructions that are easy to follow, no matter your artistic skill level. Each drawing begins with a basic shape, and each step builds on the previous, as shown below.

Within each section, you'll find instructions on how to draw each character's basic head and body before learning to create the Griffins and your favorite Quahogians in a variety of poses and getting into all kinds of miscellaneous mischief.

1 First draw the basic shapes using light lines that will be easy to erase.

2 Each new step is shown in blue, so you'll know what to add next.

3 Follow the blue lines to draw the details.

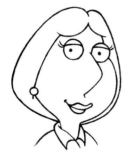

4 Now darken the lines you want to keep, and erase the rest.

5 Use crayons or markers to add color to your drawing!

MEET THE GRIFFINS

Welcome to the world of the Griffins—

a family who can't help getting into a never-ending series of crazy adventures, ranging from traveling in time to being sent to prison. Whether you think you know everything there is to know about the Griffins or if you're new to television's most anarchic animated comedy, this book is full of creative fun about the most insane family on TV.

If you're ready for jokes about pop culture, silly shenanigans, and general nuttiness, turn the page and say hello to Peter, Lois, Meg, Chris, Stewie, Brian, and their friends!

Rhode Island

As the smallest state, Rhode Island measures 37 miles across and 48 miles high. Many major U.S. cities, including Houston, Greater New York, and Los Angeles, are actually bigger than the entire state. While less than 0.5 percent of the country's population lives in Rhode Island, it is the home of the Griffins, who live in the town of Quahog (pronounced Ko-hog.)

Quahog

If you're hoping to visit this town, you're out of luck, as it isn't a real place—however it is based on one. The town is loosely patterned after Cranston, Rhode Island, a suburb of the state capital, Providence. Sometimes you can even spot Providence landmarks on the skyline behind the Griffin house.

The name isn't made up, either. "Quahog" is a type of edible clam, an idea that is taken very seriously on the show. Every year the town celebrates the myth that the city was founded by Miles "Chatterbox" Musket, who was assisted by a magical talking clam.

Spooner Street

Located west of downtown Quahog, Spooner Street is a quiet residential area and the stage for most of the *Family Guy* action. The street is named after Spooner Hill Road, which is in Kent, Connecticut, hometown of *Family Guy* creator Seth MacFarlane.

The Griffins' house, number 31, sits on an old Indian burial ground, which for some reason was left off the official map and therefore wasn't a part of the United States. This allowed Peter to establish and name himself president of the country "Petoria," which existed for about a week before the government demanded he sign over the land.

TEST YOUR KNOWLEDGE

How much do you know about the Griffins and their friends? Have you seen every episode so often you can mouth the words? Test your fan knowledge with this savvy quiz, which features specific events, people, and places (in utterly random order) from seasons 1-10. Good luck!

1 What is the name of Herbert's dog?

2 What is the name of Quagmire's dad, following her sex change operation?

3 What is the name of Lois's aunt, who leaves the Griffins her mansion when she dies, in the episode "Peter Peter Caviar Eater?"

4 In the episode "Family Gay," what causes Peter to become temporarily gay?

5 In the episode "Mother Tucker," Stewie and Brian have a radio show. What is it called?

6 Although Peter was brought up by Francis Griffin, he learns his biological father was an Irishman. What is his name?

7 In Season 1, both Peter and Lois run for the local school board elections. Which of them wins?

8 In the episode "It Takes a Village Idiot, and I Married One," the loser of the school governor contest was elected to which civic position?

9 Who donates a kidney for Peter in the episode "New Kidney in Town?" (Clue: Brian offers, but they don't end up using his kidney.)

10 The Griffin house becomes an independent nation in "E. Peterbus Unum." What does Peter call his new country?

11 In "Patriot Games," which terrible London-based American Football team does Peter get sold to?

12 What is PTV?

13 What company buys the toy factory where Peter works in the early seasons of *Family Guy*?

14 After the toy factory is bulldozed, what career does Peter pursue?

15 Peter eventually ends up working in the shipping department of which brewery?

16 Brian falls in love with an elderly shut-in in the episode "Brian Wallows and Peter's Swallows." What is her name?

17 In the episode "Believe It or Not, Joe's Walking on Air," what operation allows Joe to walk again?

18 In the episode "Blind Ambition," Peter goes blind while attempting to break which world record?

19 Peter's other maladies include having a stroke, but what caused him to have it?

20 Chris gets a talking pimple in the episode "Brian the Bachelor." What is it called?

21 In "The Thin White Line," what ends Brian's law-enforcement career as a drug sniffer dog?

22 Chris gets expelled from James Woods High in "No Chris Left Behind." Which incredibly posh school does his grandfather help him get into next?

23 In the episode "Be Careful What You Wish For," Peter, Joe, and Quagmire head out to sea with a net and a plan. They inadvertently capture a talking dolphin named Billy Finn, but what were they originally trying to catch?

24 In "I Take Thee, Quagmire," what is the name of the woman Glenn marries?

25 And what is the name of Quagmire's daughter, who's left on his doorstep in "Quagmire's Baby?"

26 One more Quagmire question: What is Glenn's day job?

27 In the episode "April in Quahog," what does Peter confess moments before he thinks the world will end?

28 What happened to Brian's mother after she died?

29 Why does Chris join the Peace Corps and run away to South America in the episode "Jungle Love?"

30 What is the title of the very first episode of *Family Guy*?

CHECK YOUR ANSWERS ON PAGE 128!

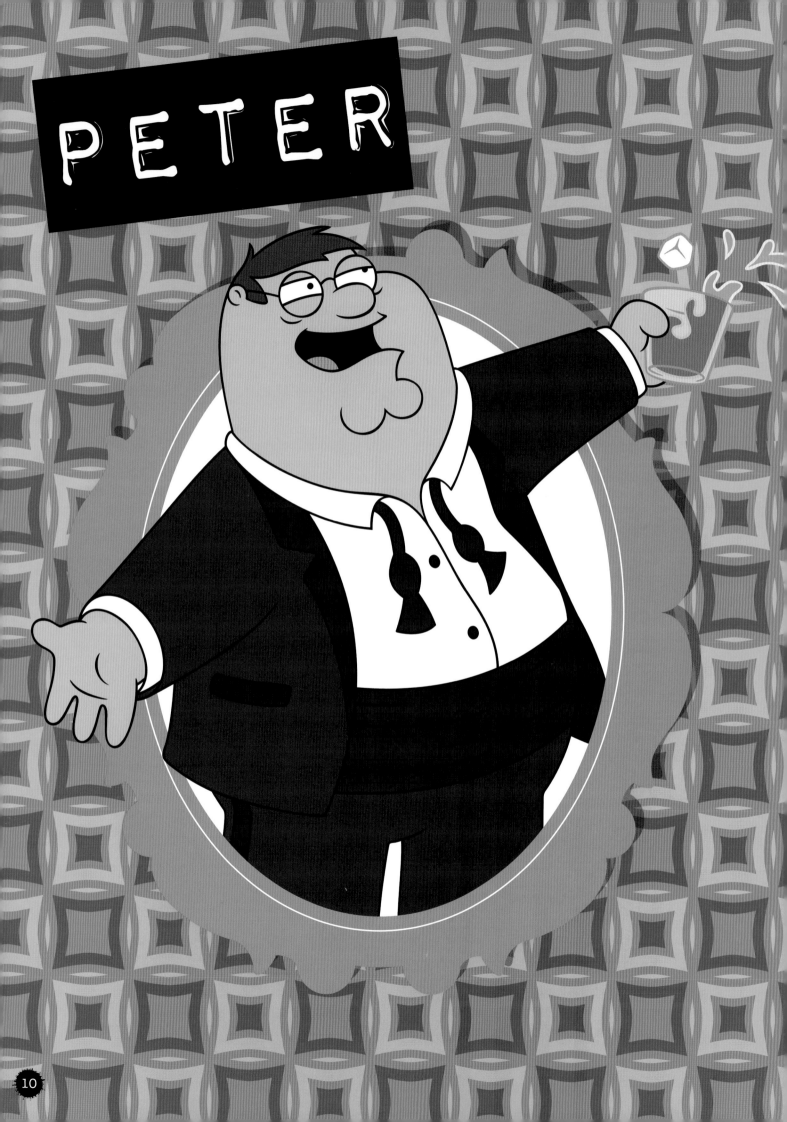

PETER

Peter Griffin is a big, boisterous, loveable oaf who isn't afraid to say what's on his freakin' mind—usually the wrong thing at exactly the wrong time. He lives in the suburbs of Quahog, Rhode Island, with his wife, Lois; their three children Chris, Meg, and Stewie; and his well-spoken best friend, Brian, the family dog. Peter would do anything for his family, as long as it doesn't get in the way of his TV time.

Peter's relaxed attitude toward work has taken him through several jobs. Over the years of *Family Guy*, he's worked in a toy factory, on a boat—the gloriously christened "S.S. More Powerful Than Superman, Batman, Spider-Man, and the Incredible Hulk Put Together"—and most recently, a brewery. He's also been a maid, bartender, school-board president, tobacco lobbyist, erotic book author, policeman, president of his own country, Renaissance fair Jouster, and even Death for a short stint.

What Peter lacks in common sense and good judgment, he makes up for with enthusiasm. He often goes overboard when he latches onto an idea. Whether he's leading an improvisation scene during a bank robbery or running barefoot in the rain with has-been actors, Peter Griffin is always looking for fun.

Although Peter was 30 years old the very first time he had gas, he's been making up for it ever since. He recently ripped the longest fart in television history. When asked to comment on the eruption, Peter merely replied, "Hehehehe."

BIRD ≡ WORD

hehe heheh!

"I'm a **bad** father, a **lousy** husband, and a **snappy** dresser."

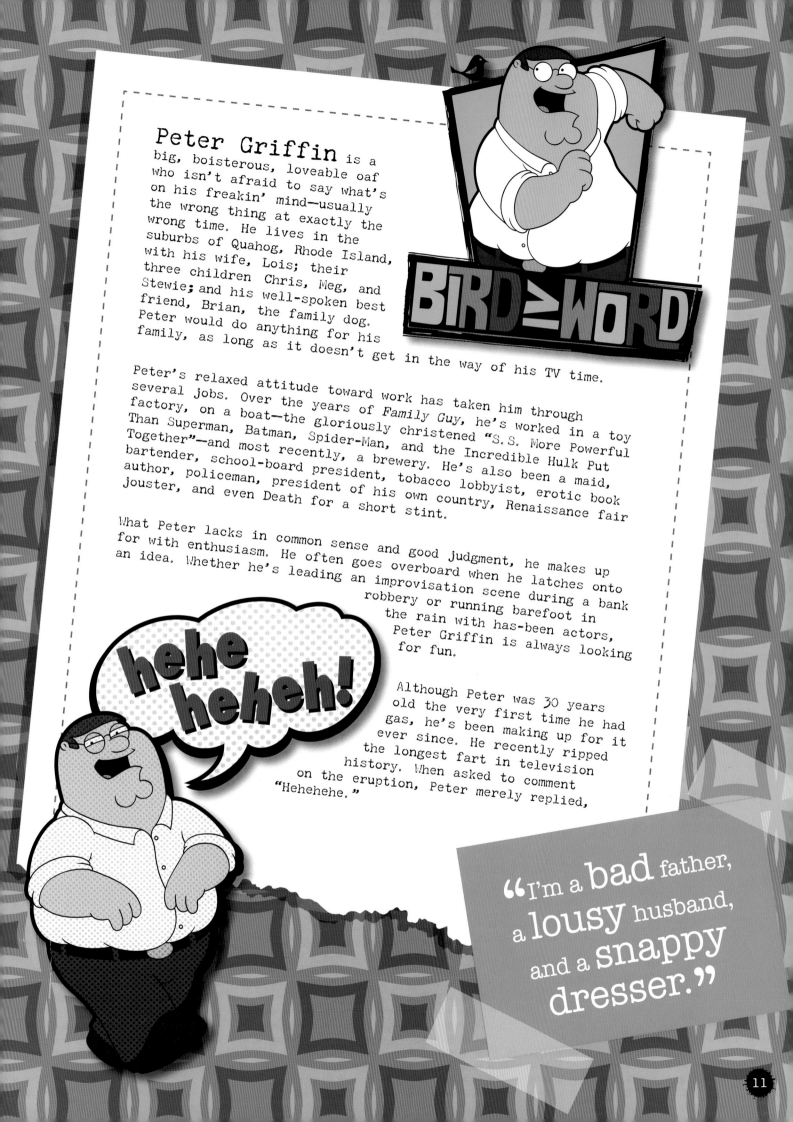

PETER'S HEAD

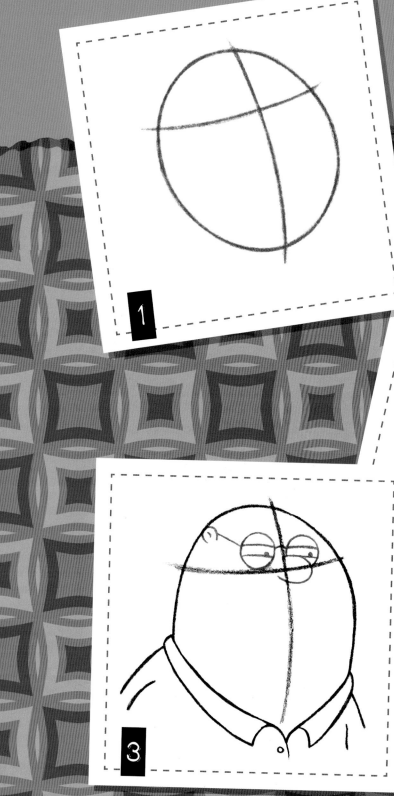

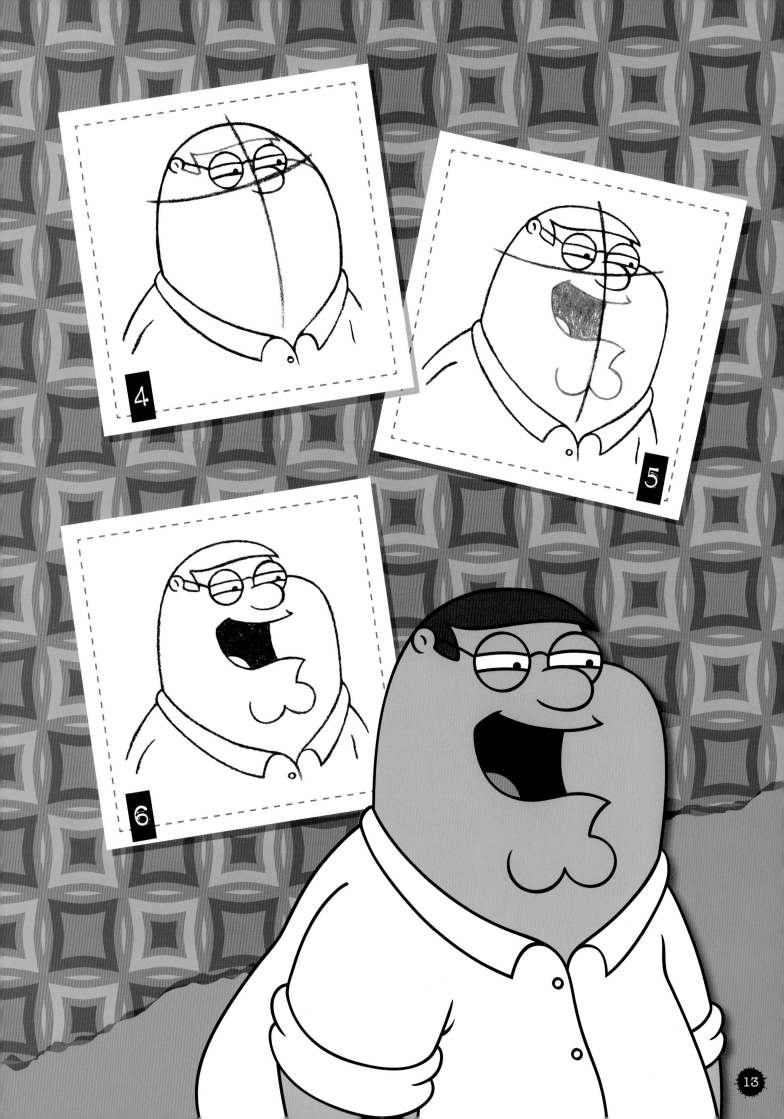

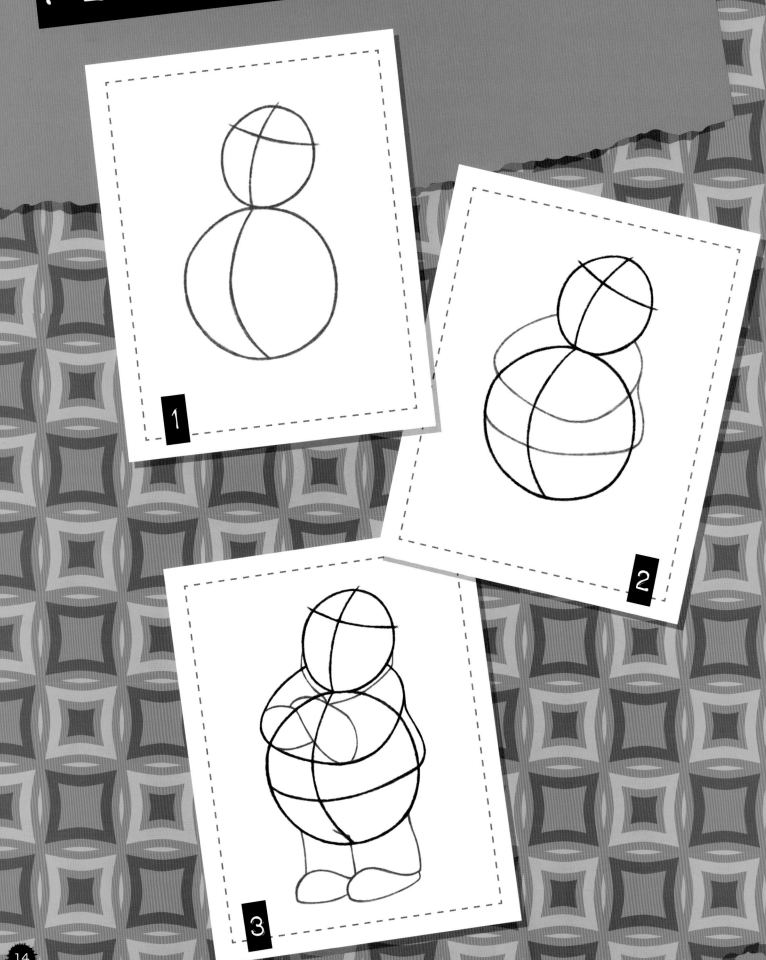

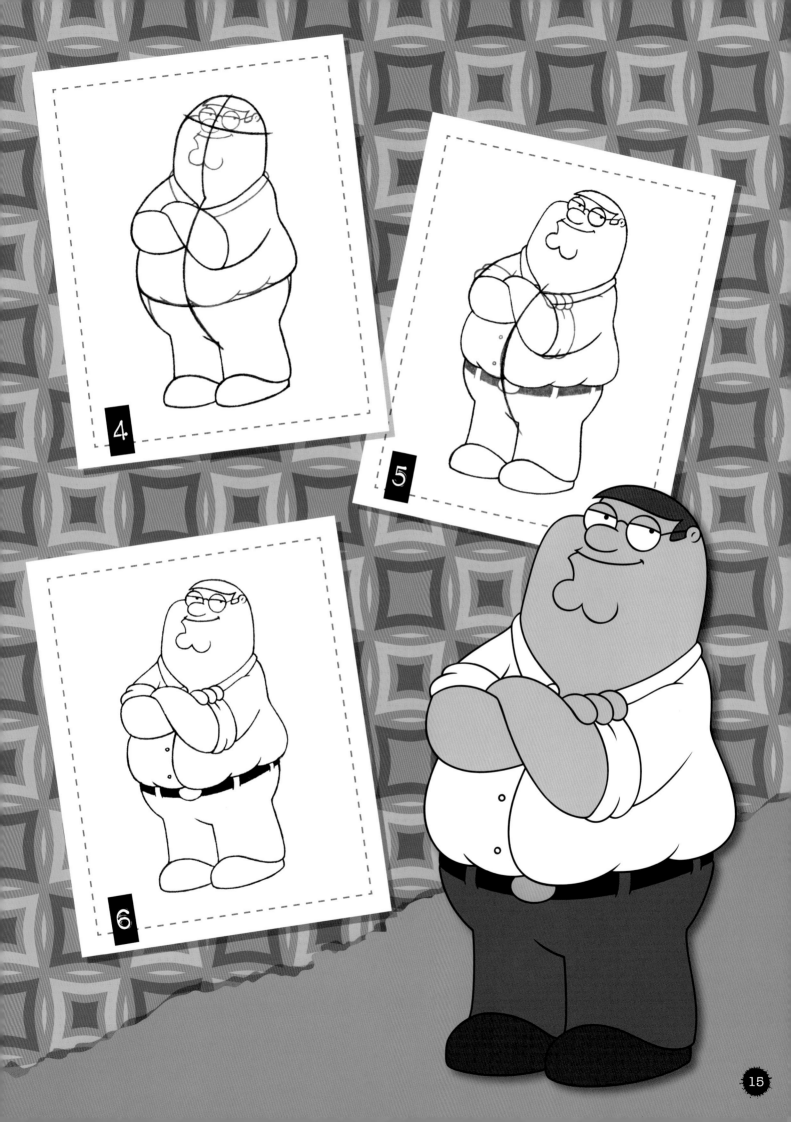

4.

5.

6.

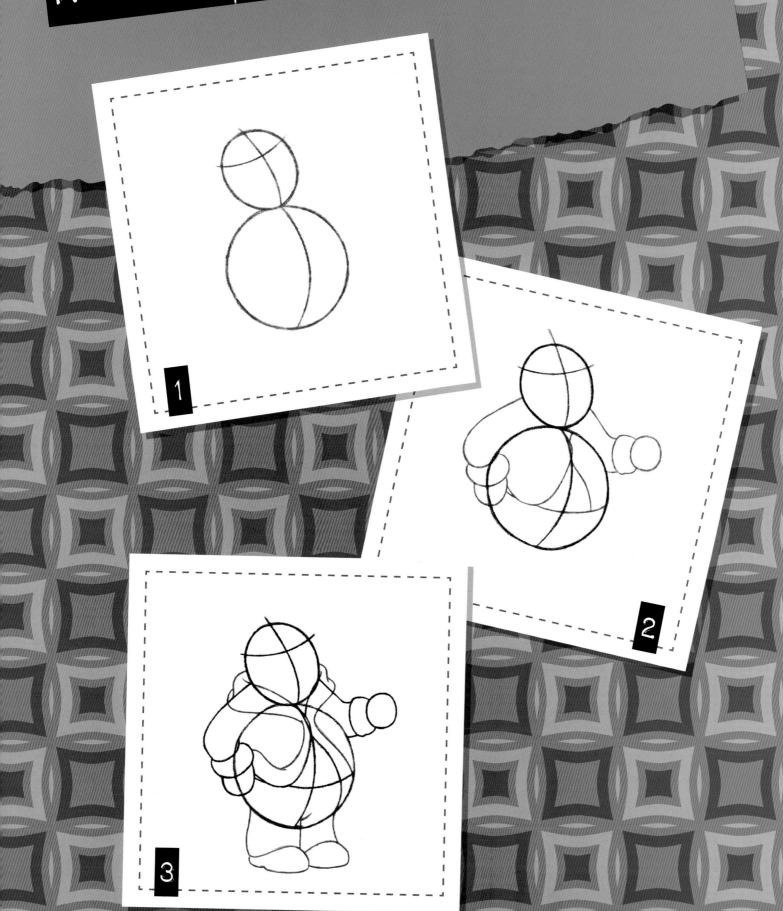

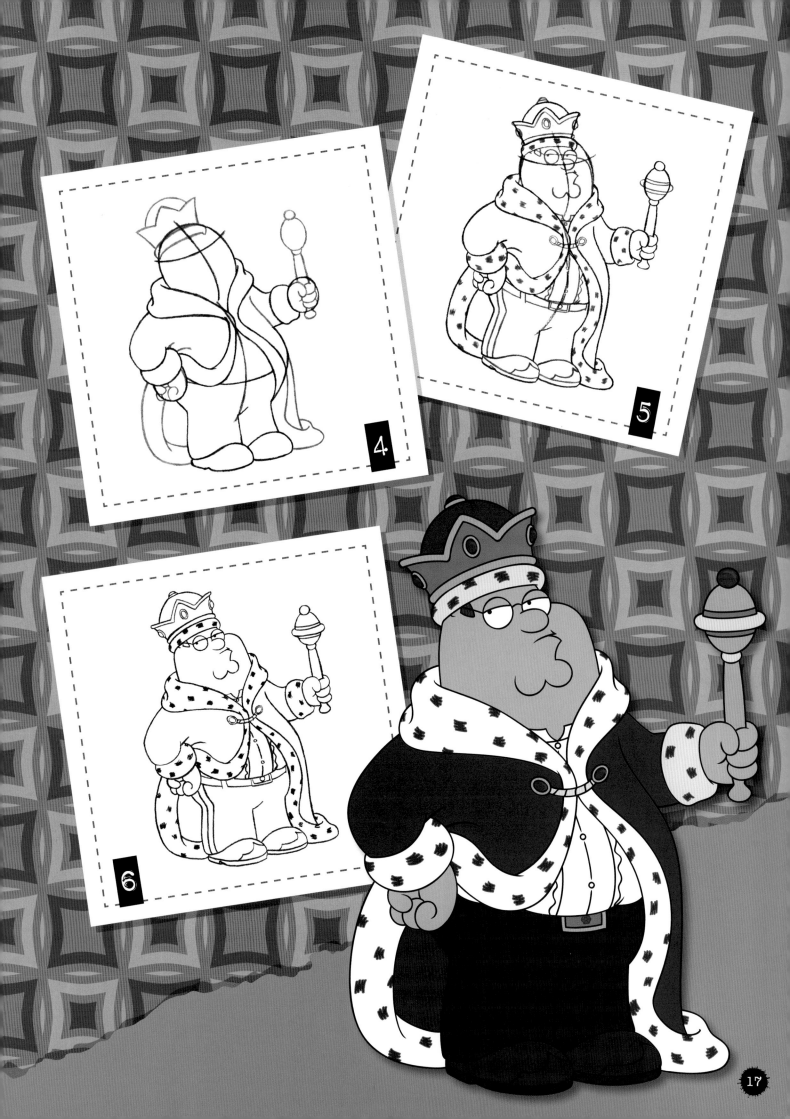

DADDY ON DUTY

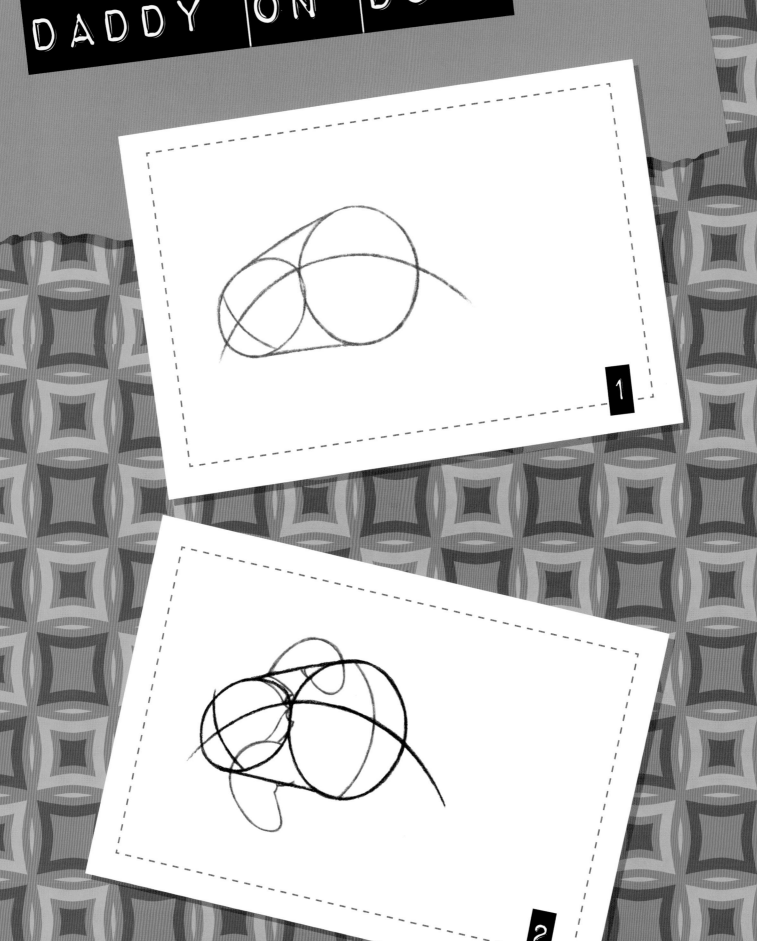

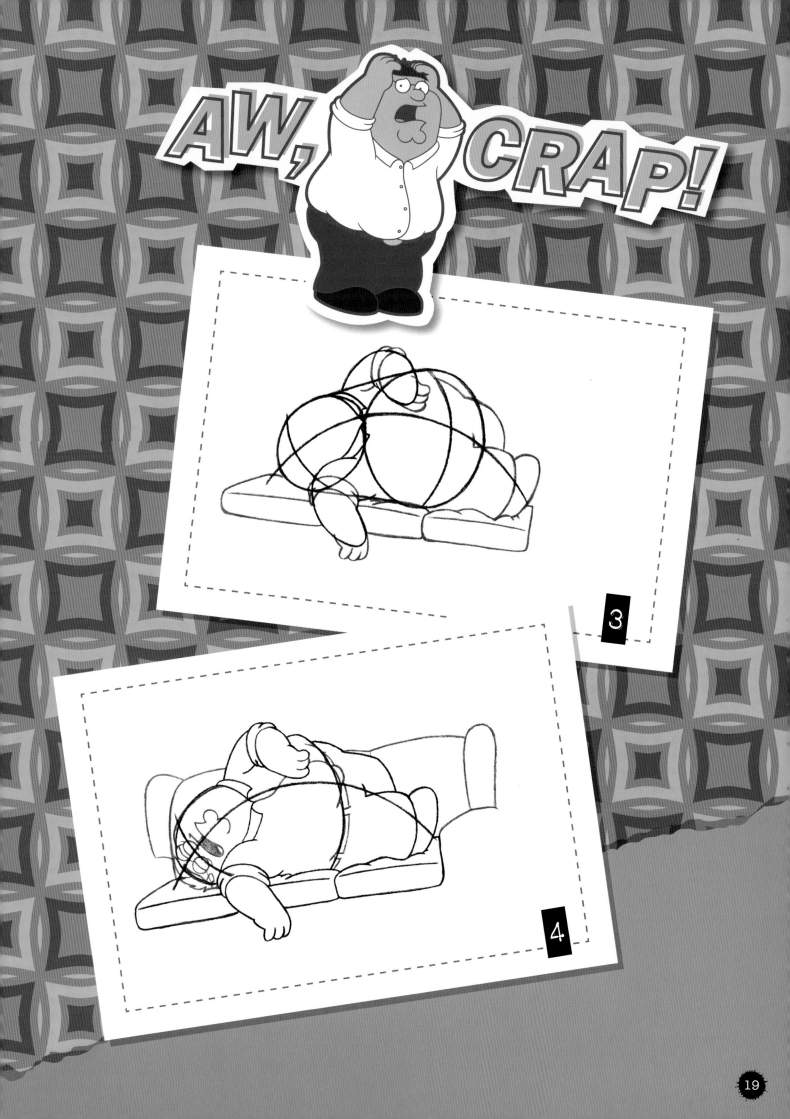

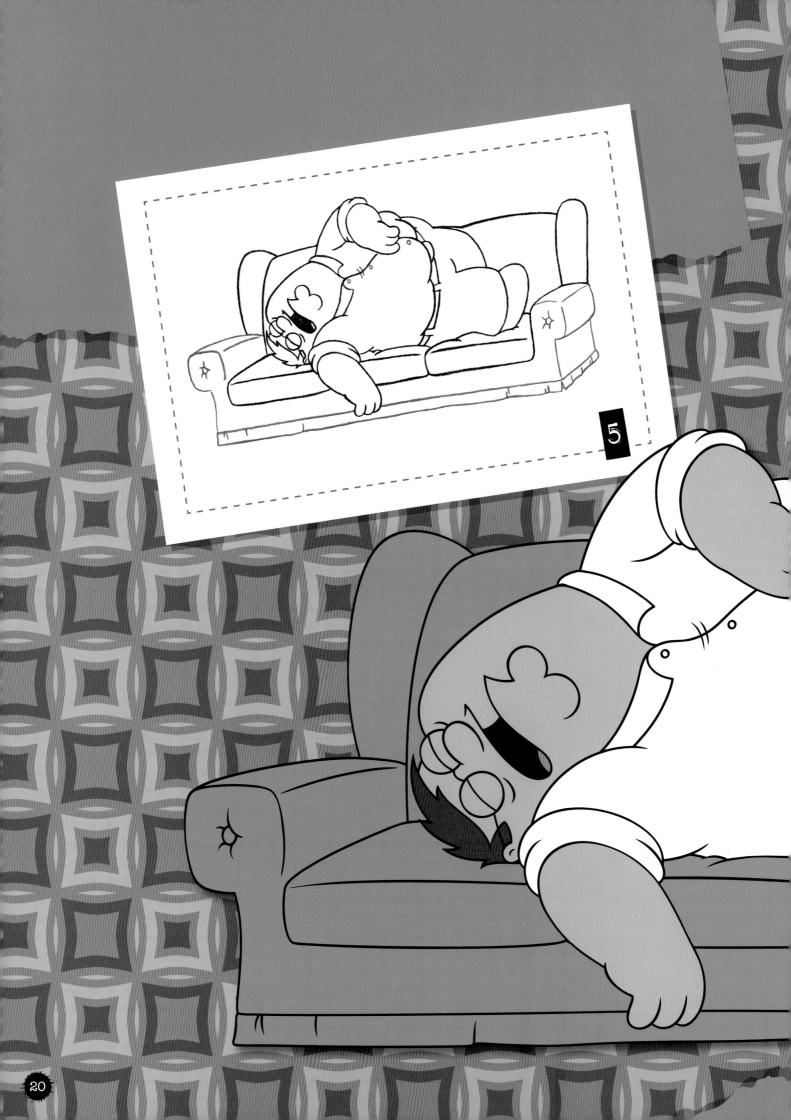

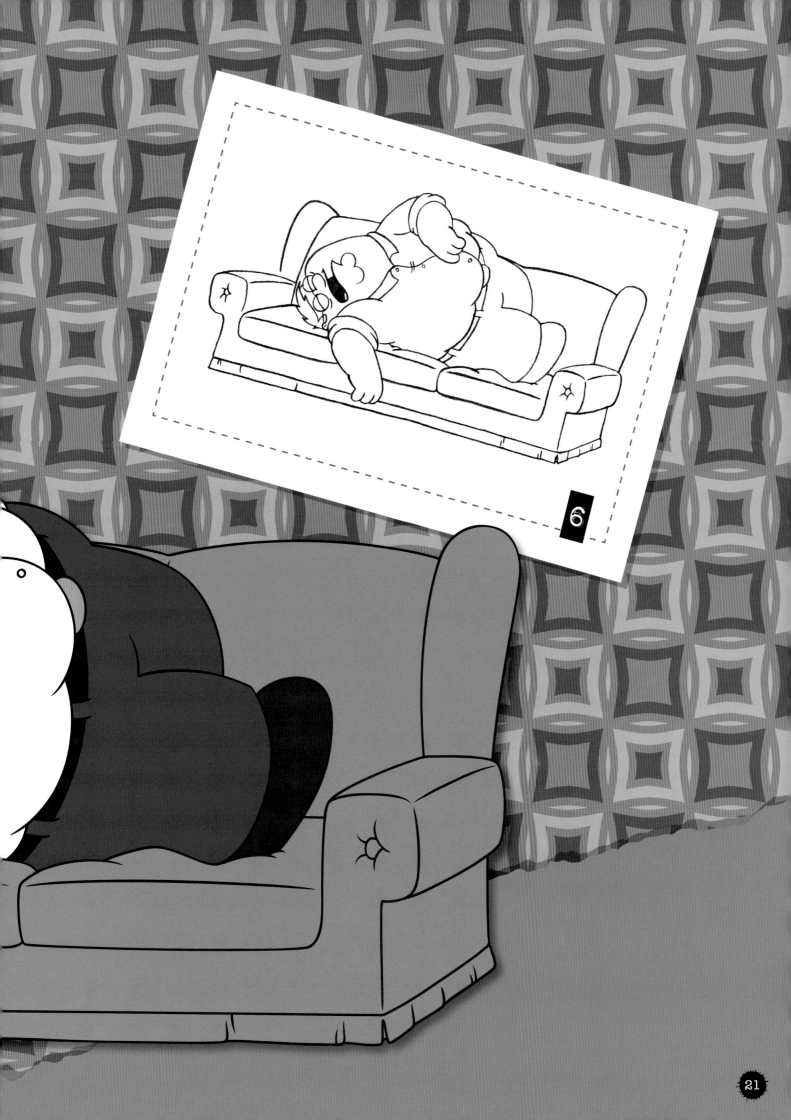

MORE PETER!

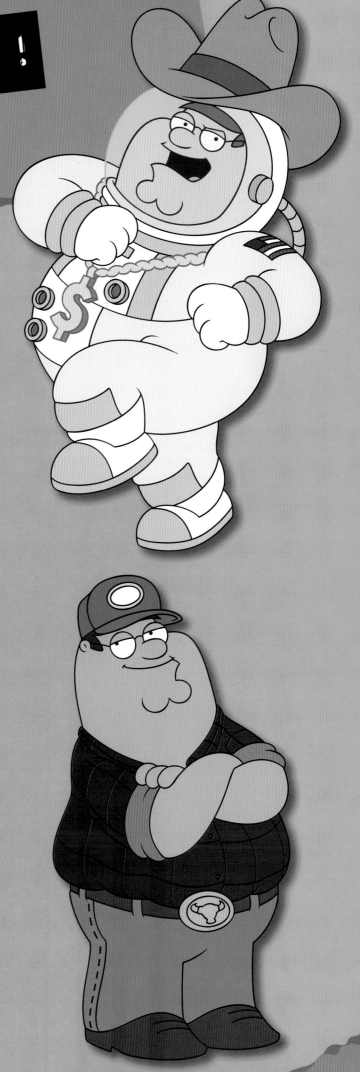

> "I got an idea...an idea so smart, my head would explode if I even began to know what I was talking about."

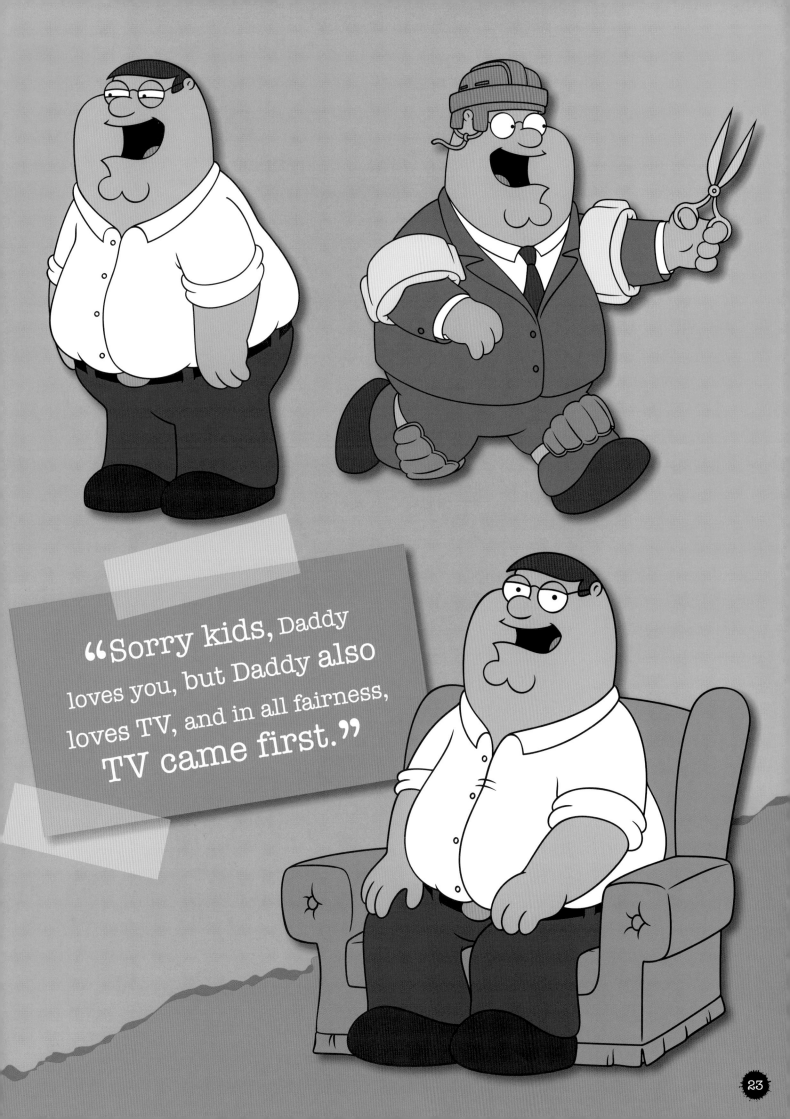

"Sorry kids, Daddy loves you, but Daddy also loves TV, and in all fairness, TV came first."

LOIS

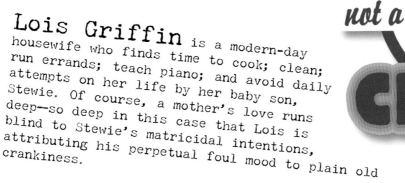

Lois Griffin is a modern-day housewife who finds time to cook; clean; run errands; teach piano; and avoid daily attempts on her life by her baby son, Stewie. Of course, a mother's love runs deep—so deep in this case that Lois is blind to Stewie's matricidal intentions, attributing his perpetual foul mood to plain old crankiness.

Born in upper-crust Newport, Rhode Island, the one-time heiress to the Pewterschmidt family estate gave up the privileged life to be with the towel boy she fell in love with. She hasn't looked back since. No matter how many times Peter falls down (in some cases due to too many Pawtucket Patriot beers), Lois is right there to pick him up again.

Lois is generally the voice of reason that Peter can't hear until it's too late; however, even Lois has been known to temporarily lose her senses. In fact, rumor has it that she's put on bold and seductive piano performances right in the family's basement. Once Lois's crazier side is released, she likes to take things to the extreme—such as becoming a crazed kleptomaniac or losing the family's car at an Indian casino. She's also good looking and has a killer body, which sometimes makes Peter feel inadequate. It also sends their sex-crazed neighbor, Quagmire, into a fervor, and has caused Brian the dog to be intensely infatuated with her.

Lois is a complex and mysterious woman. Think Martha Stewart meets Barbarella.

HOT MOM

"I'm going through a phase... where I'm only attracted to handsome men."

LOIS'S HEAD

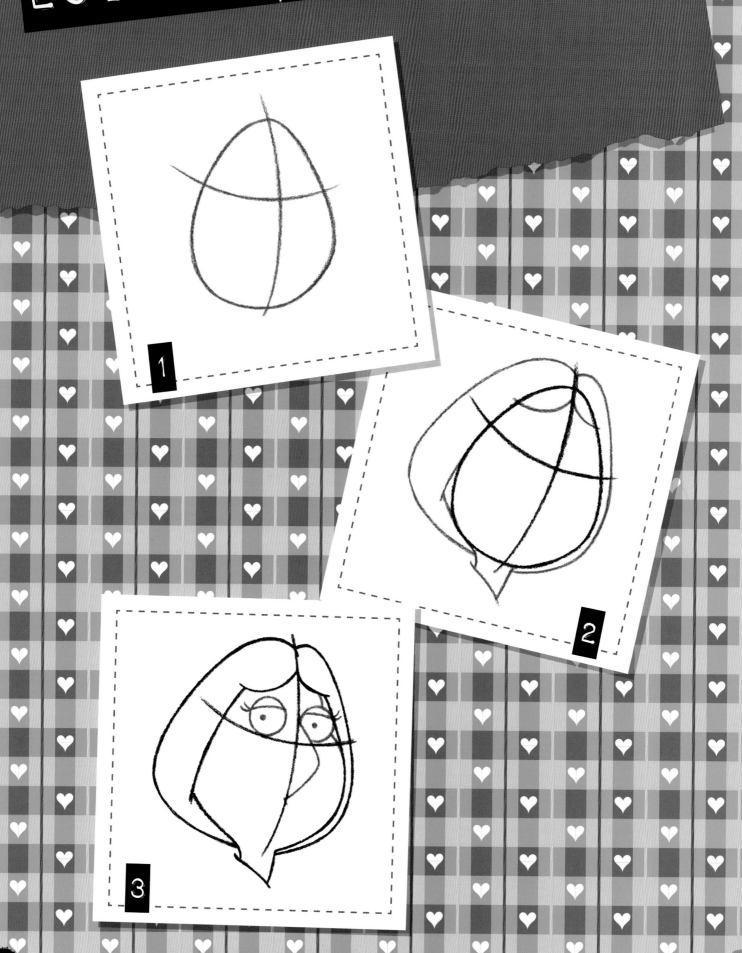

1

2

3

26

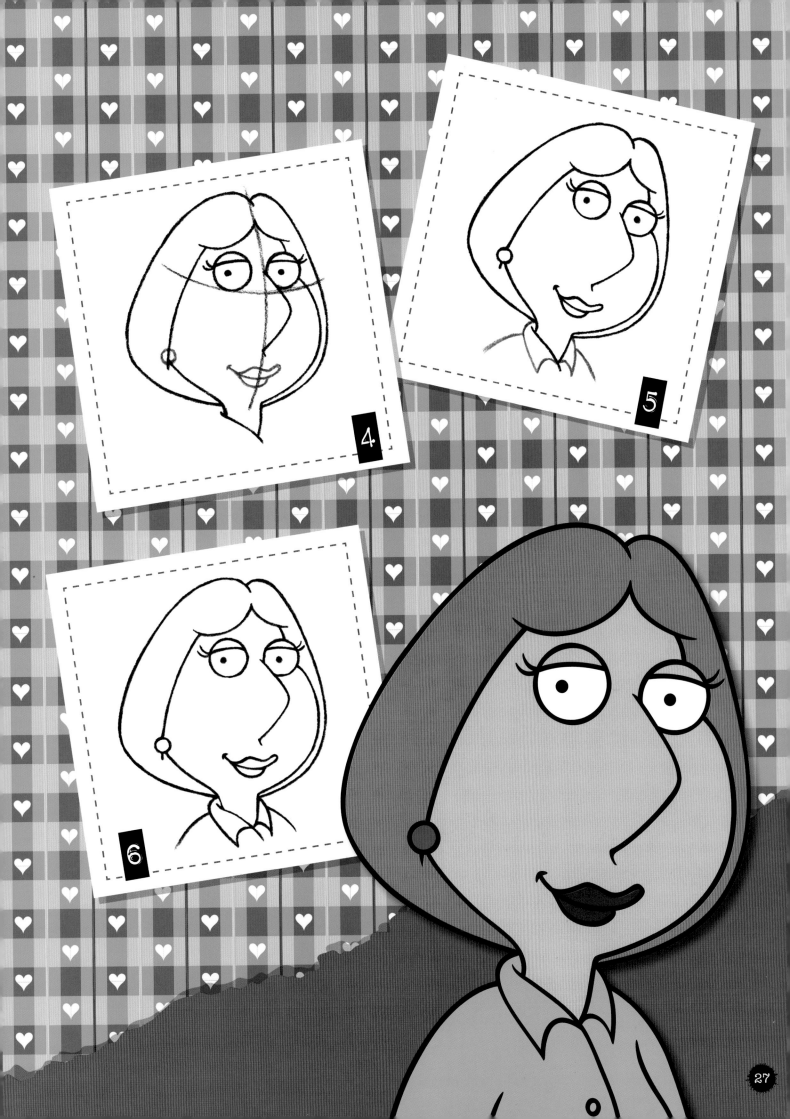

4

5

6

LOIS'S BODY

1

2

3

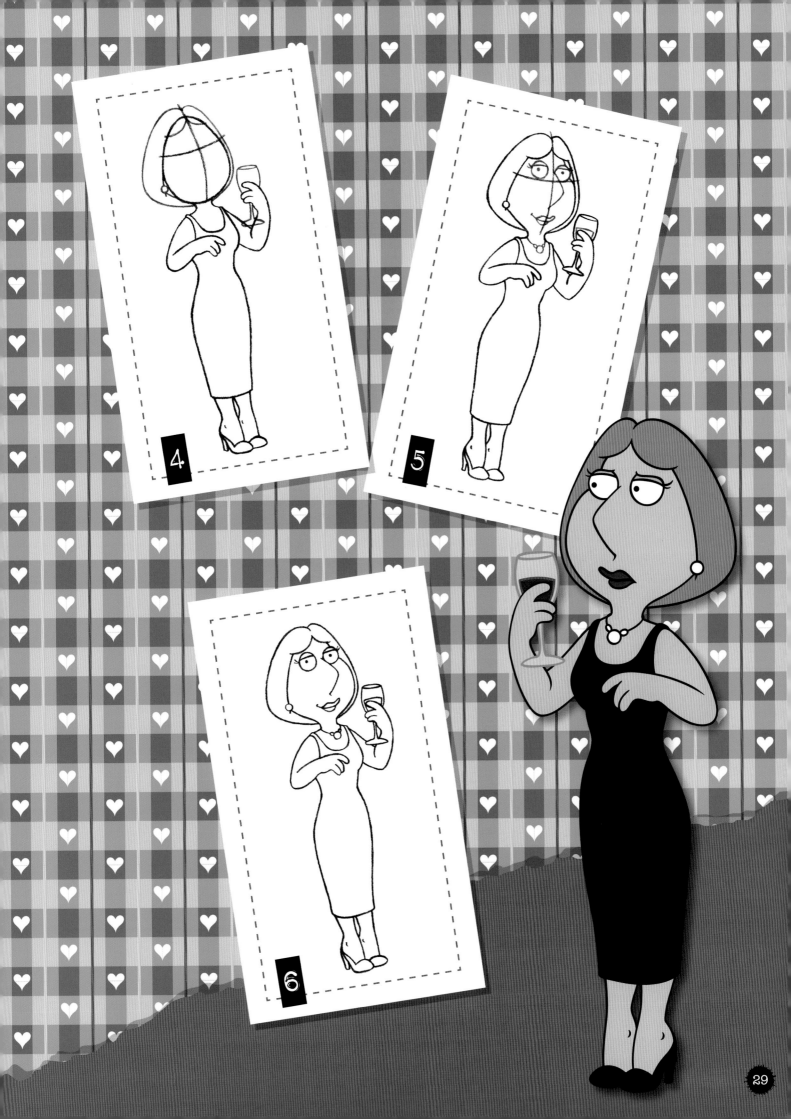

"MOM! MOMMY! MA! MUM! MUMMY! MOMMA!"

1

2

3

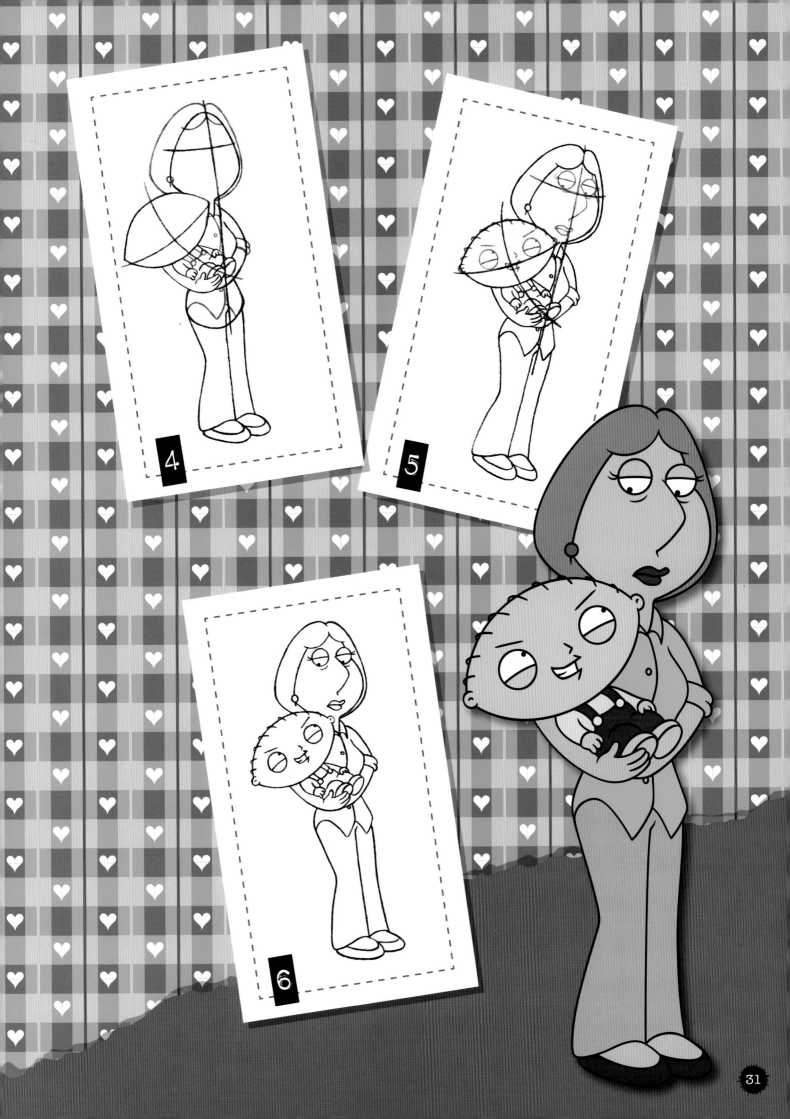

4

5

6

MORE LOIS!

RED HOT mama

> "My daughter needs a makeover like there's no frickin' tomorrow."

"I just wish my opinion mattered to you."

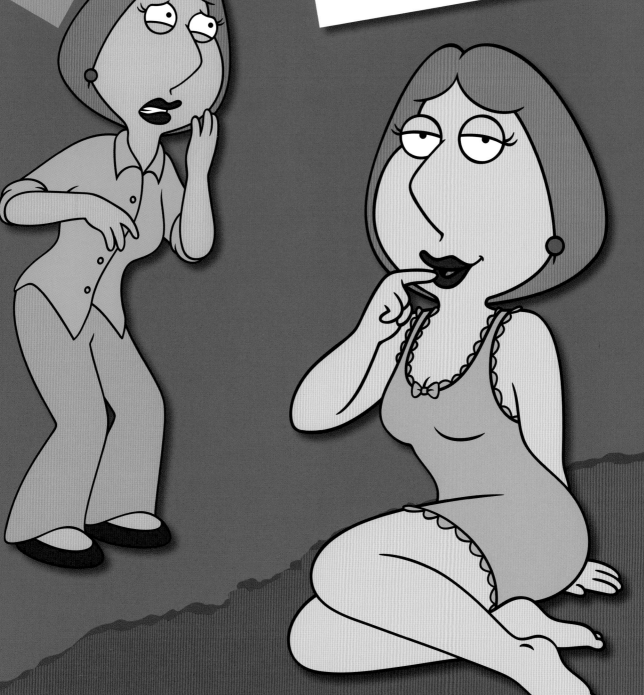

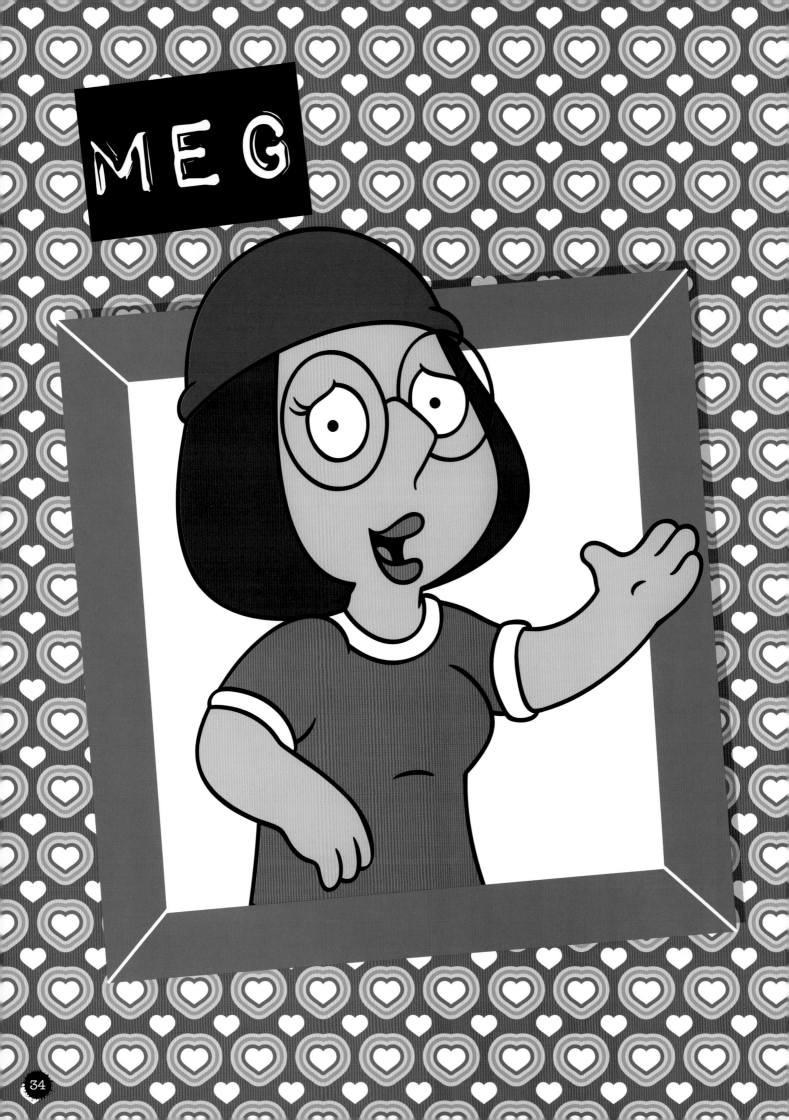

MEG

You don't know anything about me!

Sixteen-year-old **Meg Griffin** is perennially unpopular. The beanie-hat obsessed, eldest child of Peter and Lois is a total outsider at school and at home. Her parents have even decided that if they had to leave one child behind in an emergency, she'd be the one. It's not much fun being Meg.

The constant butt of the joke, Meg is forever reminded of what a loser she really is. She is constantly struggling to gain acceptance from the "in" crowd—or any crowd for that matter. A bit of a drama queen, Meg pines for her hunky new neighbor, Kyle. Unfortunately, not even a clingy new dress or a designer bag seem to get her any closer to first base. Even when it looks like things are going right for her, everything goes bad, like the time she had to accept a pity date from the family dog because she couldn't get a real date to the prom.

Like most girls her age, Meg is often embarrassed by her family. However, most girls don't have Peter Griffin as their father, who has turned embarrassment into an art. He once interrupted Meg's class to chide her about shaving her legs in the shower, complaining, "It's like a carpet in there!"

But Meg will survive. And one day she'll get the popularity she so richly deserves. Yeah, right.

I'M JUST TRYING TO FIT IN!

"It's Saturday night. I could be out having a life."

35

MEG'S HEAD

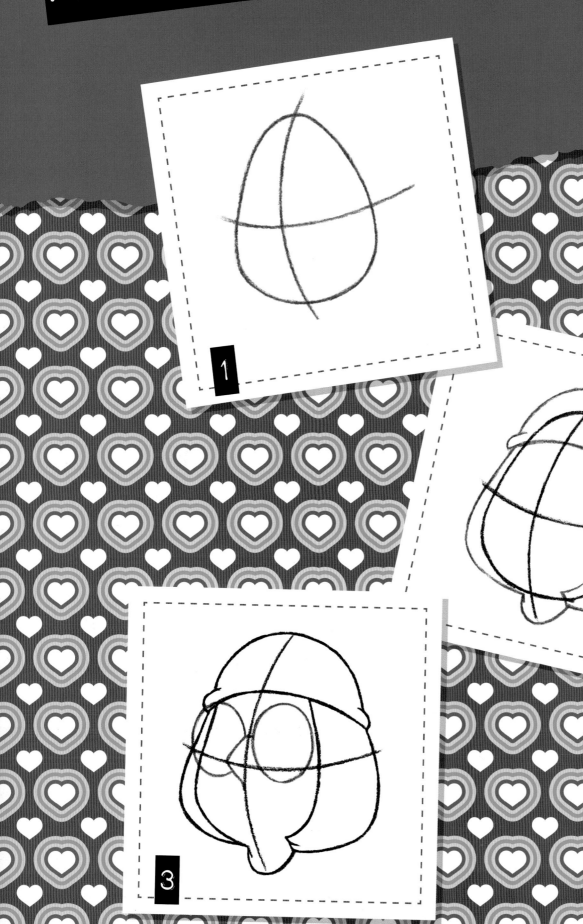

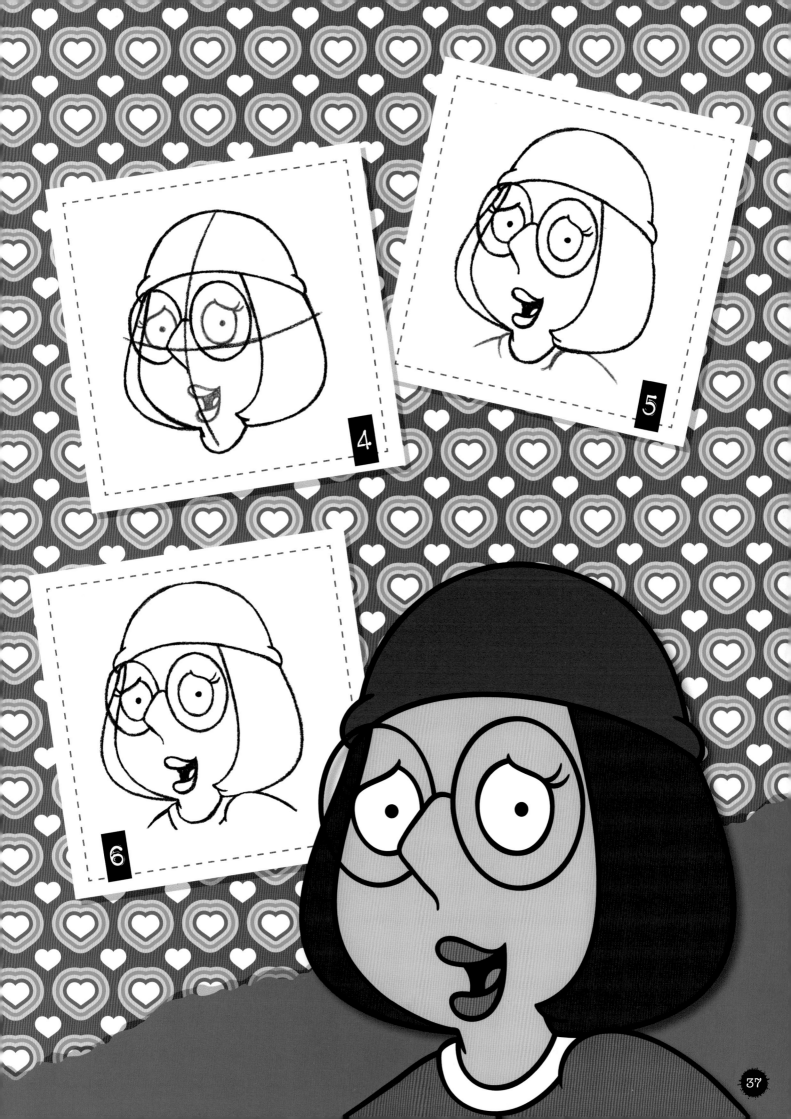

1

2

3

4

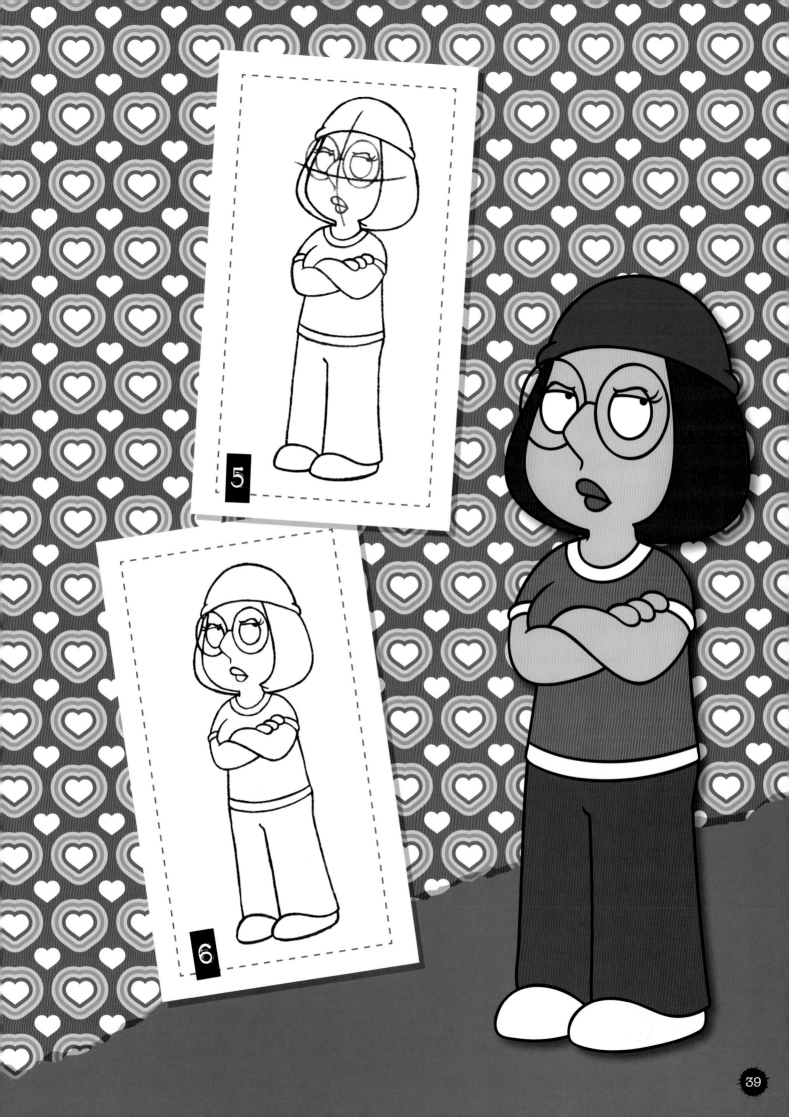

"I'M JUST TRYING TO FIT IN!"

1

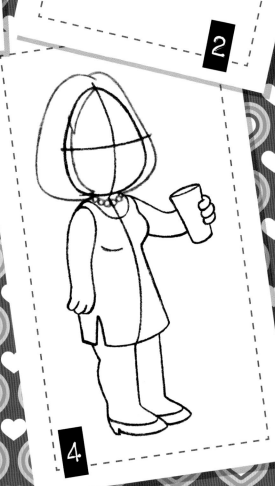

2

3

4

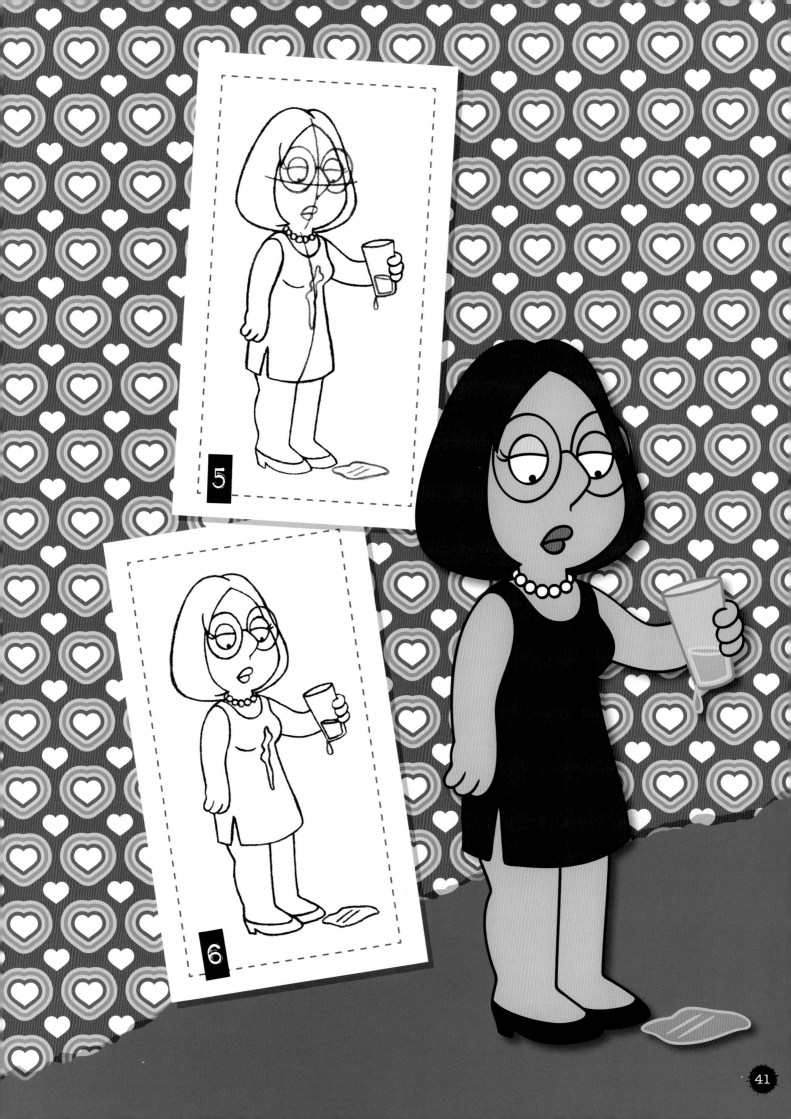

MORE MEG!

Loser

"I'm not a boy!"

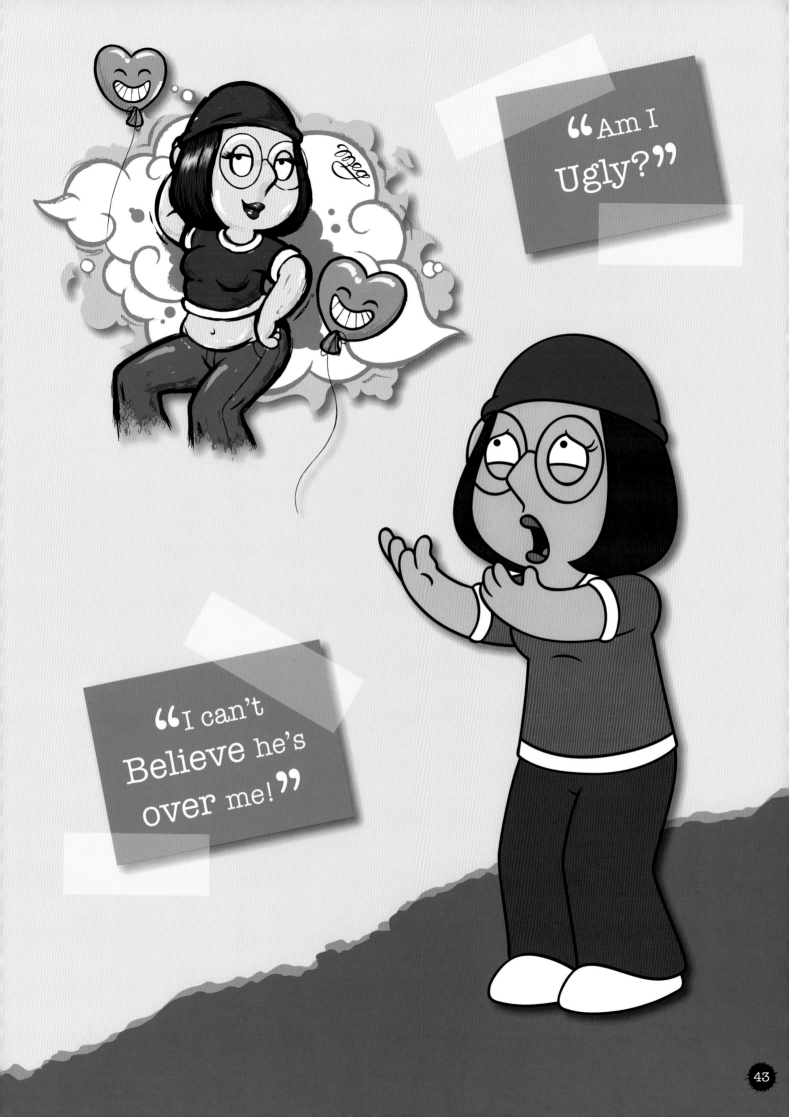

43

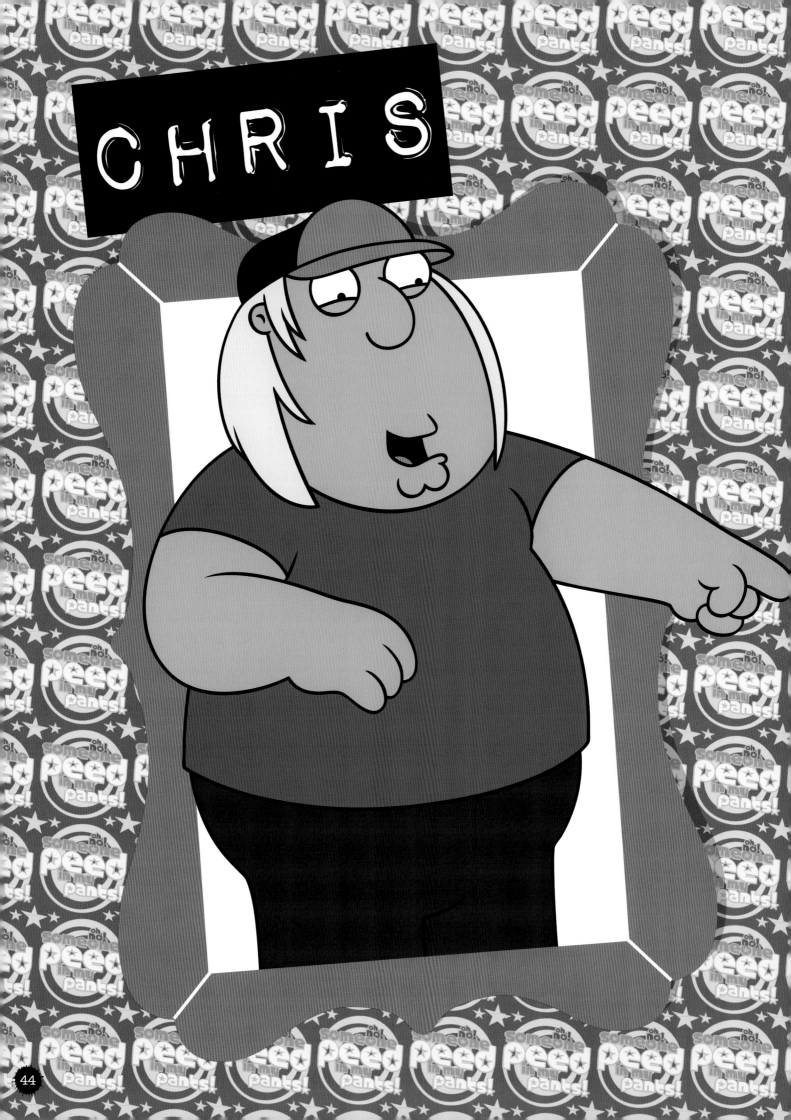

CHRIS

• ADULT • SUPERVISION REQUIRED

Chris Griffin

is an overgrown, sweet-hearted 13-year-old who looks imposing, but secretly wouldn't hurt a fly. (Unless it landed on a hot dog, his favorite food. In that case, Chris would probably treat the fly as a condiment.)

In his mid teens, Chris has to deal with many of the normal problems of puberty, from bodily changes and acne (his spots have been known to take on a life of their own) to girls and school. Chris doesn't have many friends, though, and often keeps to himself, sometimes spending time alone in his bedroom—or so you might think. He was, in fact, formerly tormented by an evil monkey that resided in his closet. Though Chris shared tales of the pointing sneering primate with his parents, they were forever indifferent to his cries.

Chris idolizes Peter and works hard not to disappoint him. It's good for Chris that his father's expectations are so low. Still, Chris does have some hidden talents, especially his ability to draw. He should probably spend more time cultivating this skill and less time with Peter in front of the boob tube looking for actual boobs.

A true individual, Chris lumbers to the beat of his own drum. Although physically he matured early, he still has a ways to go intellectually. But just because he's still not clear on where babies come from doesn't mean he's not eager to learn.

Permission to FREAK OUT?

"There's an Evil Monkey in my closet!"

45

CHRIS'S HEAD

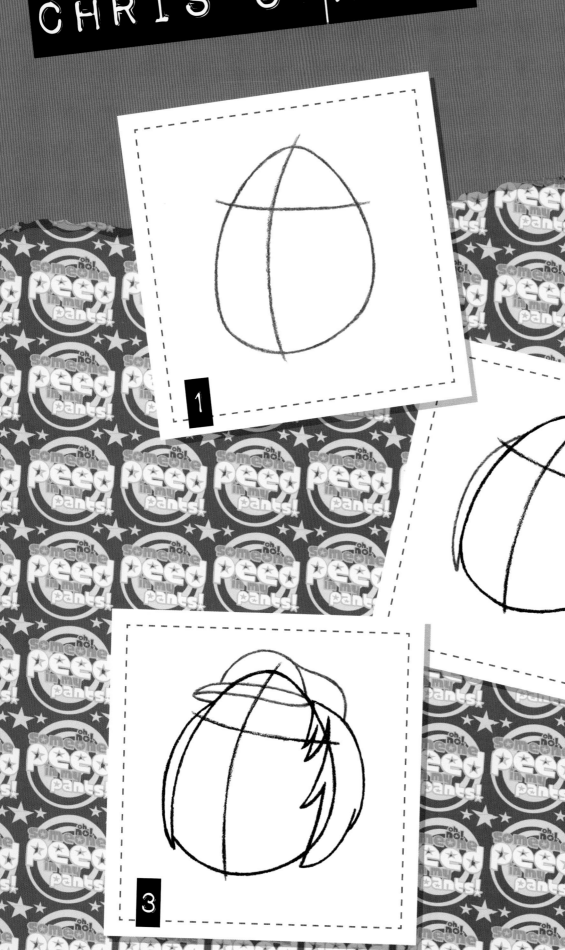

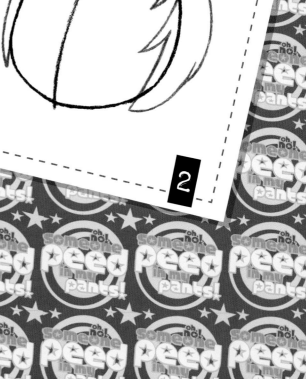

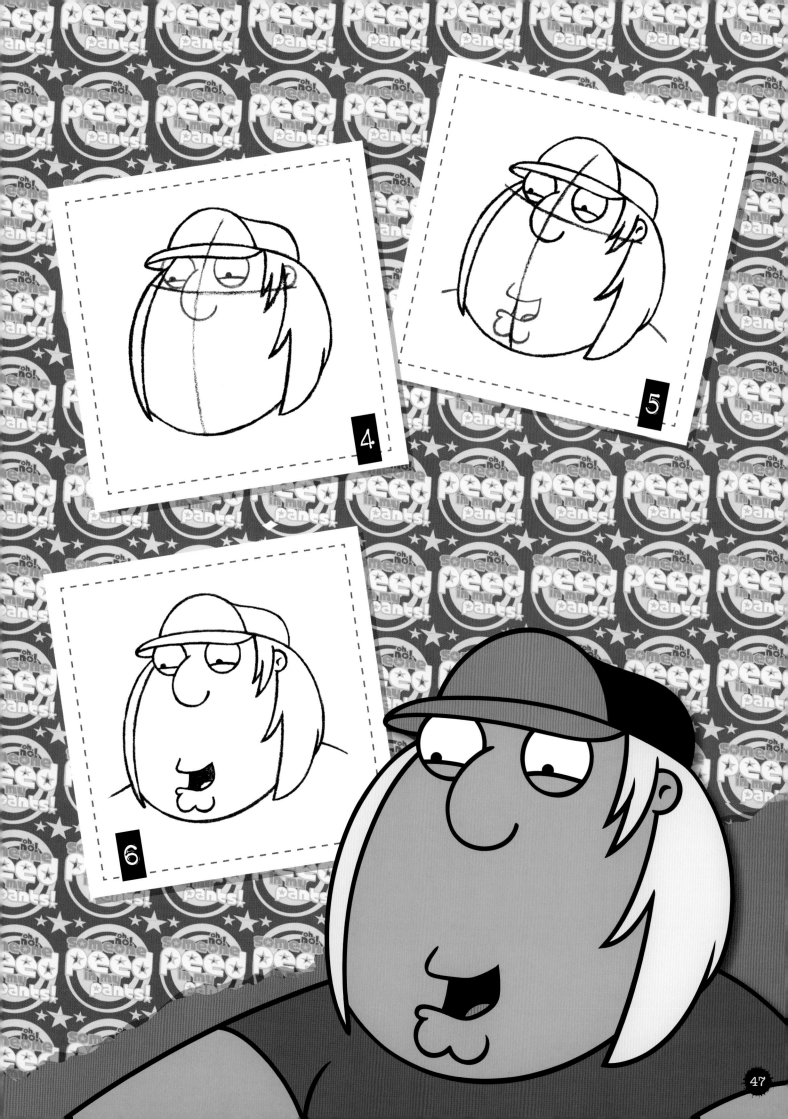

CHRIS'S BODY

1

2

3

4

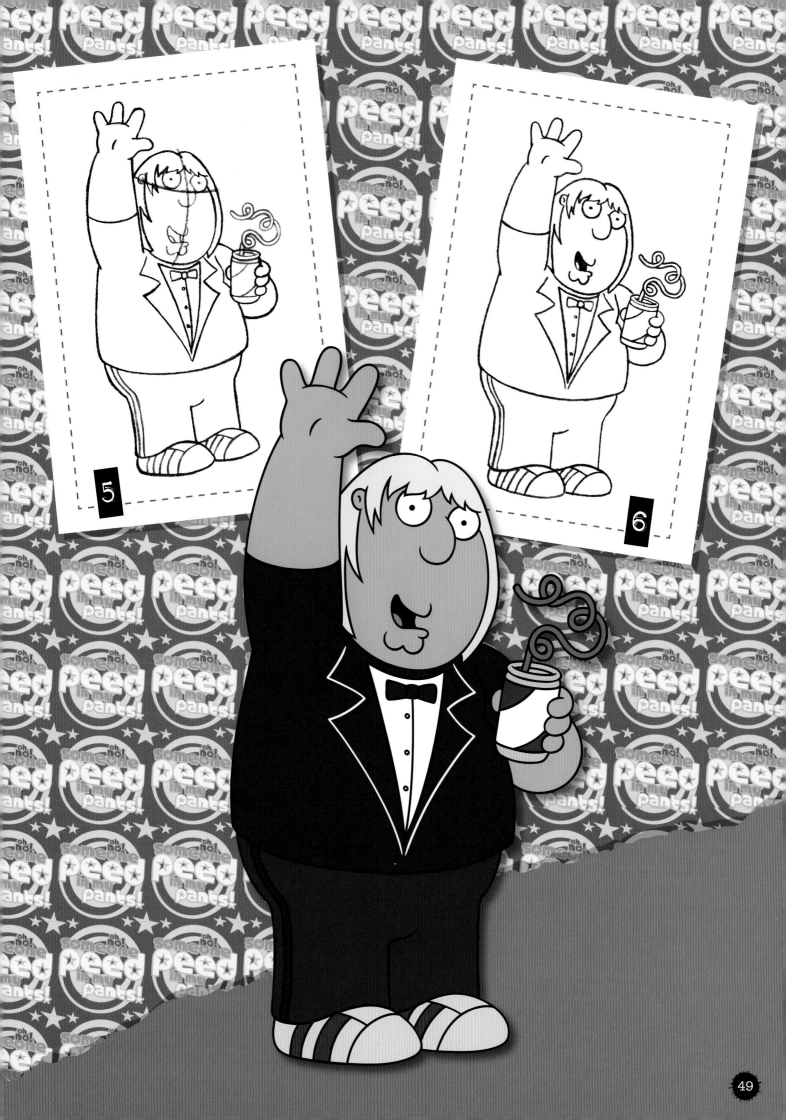

"PERMISSION TO FREAK OUT?"

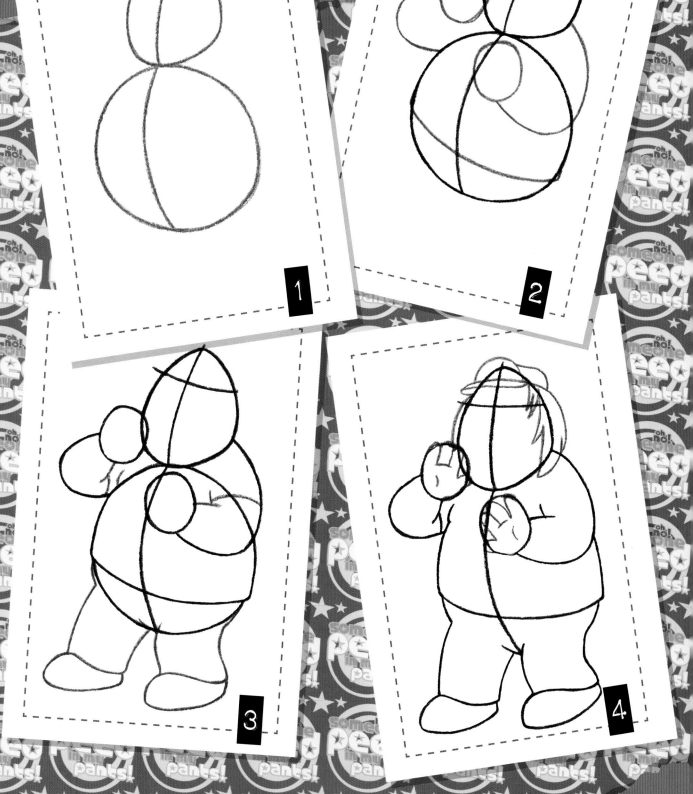

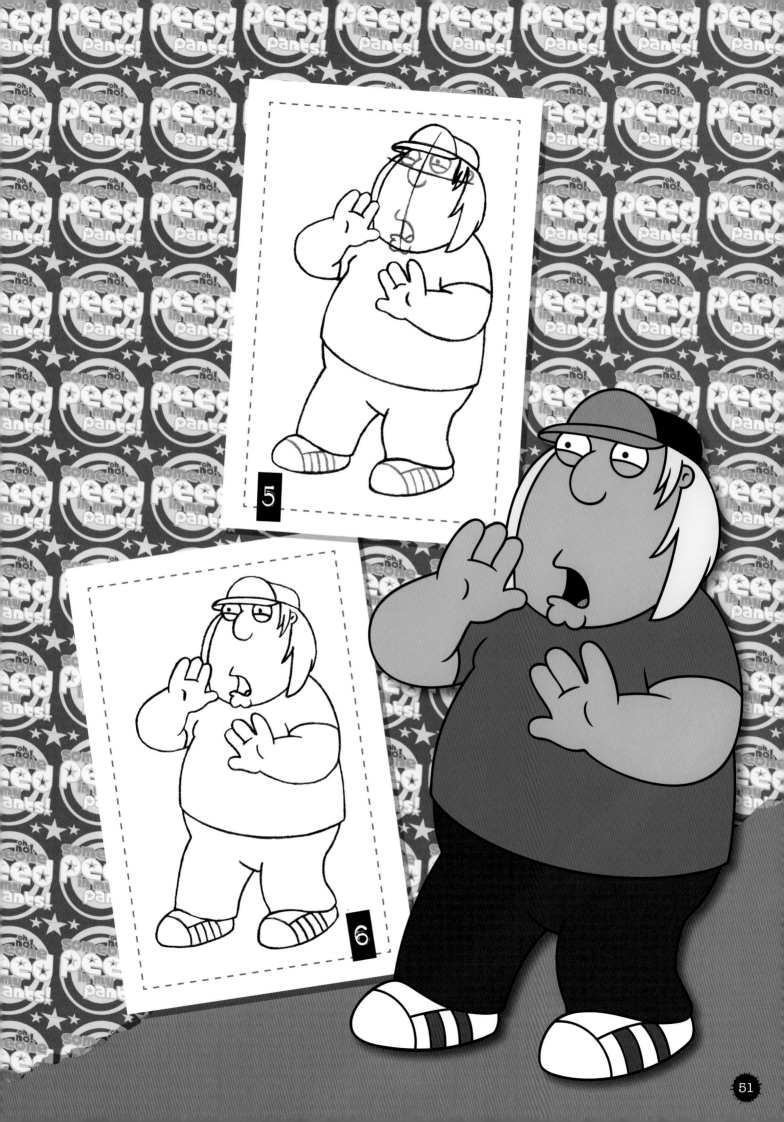

oh no! someone peed in my pants!

"I don't like being touched!"

"I'm turning you into poo!"

Stewie Griffin

is a 1-year-old baby with a single goal: Total World Domination. He has the voice and manner of an evil Rex Harrison, but he's only recently celebrated the one-year anniversary of his escape from his mother's "cursed ovarian Bastille," in which he was incarcerated for nine grueling months. Stewie once made a vow to defeat his mother's matriarchal tyranny and topple the "gynocracy" she rules. Many of his schemes have been designed with this goal in mind.

WHY YOU SICK, SICK, SICK LITTLE moo COW!

WHAT the DEUCE ARE YOU STARING AT?

Lois has narrowly escaped several attempts on her life thus far—from a box of chocolates filled with active grenades to a barrage of arrows shot straight at her head. As for everybody else, if it were not for his lack of muscle tone, toilet training, and his need for parentally provided sustenance, Stewie would have already gained control over most of the third world, including Canada.

Several of his inventions—including time travel pods and a box that turns his brother Chris into a human puppet—have been the result of simply wanting to keep his killer instincts sharp. And if he can create a machine that controls the weather, what makes you think he won't be able to control you, hmmm?

"What if I make a fudgie?!"

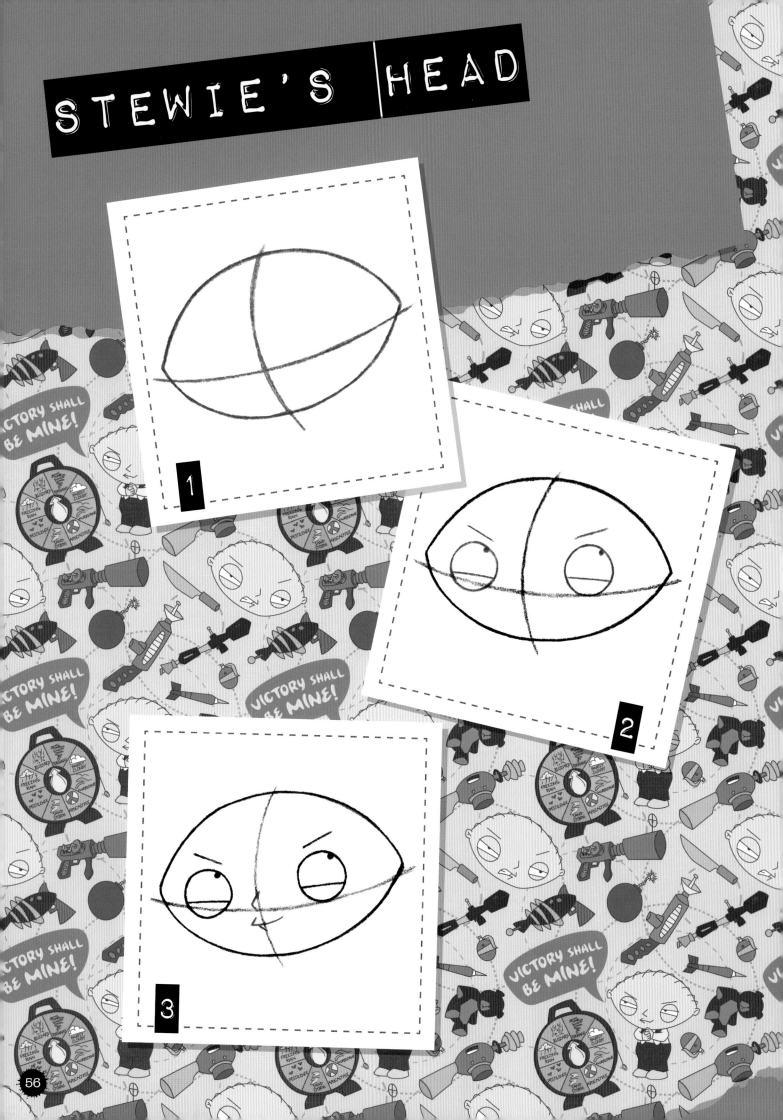

1

2

3

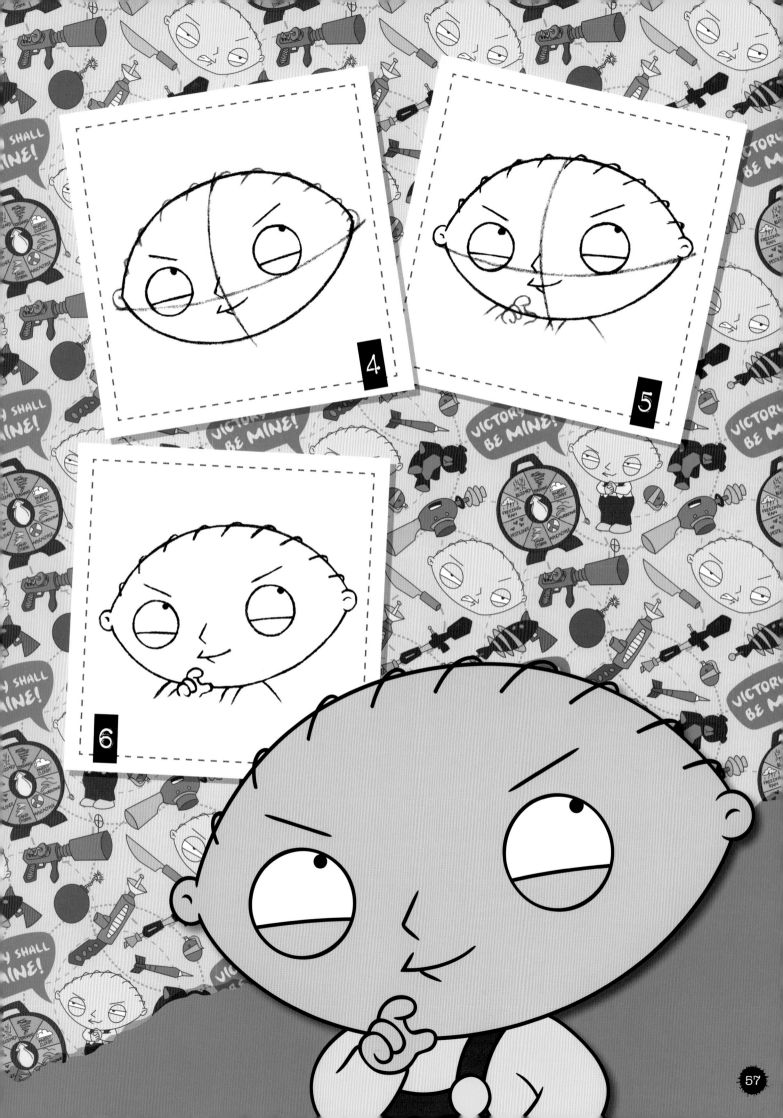

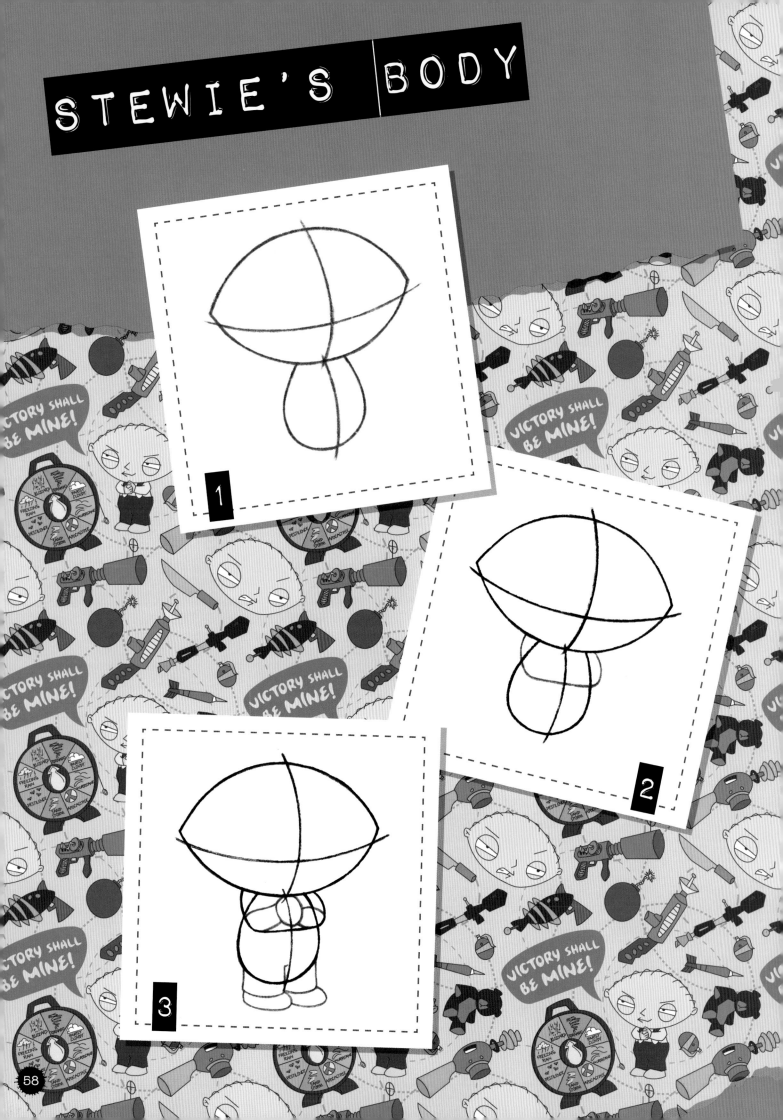

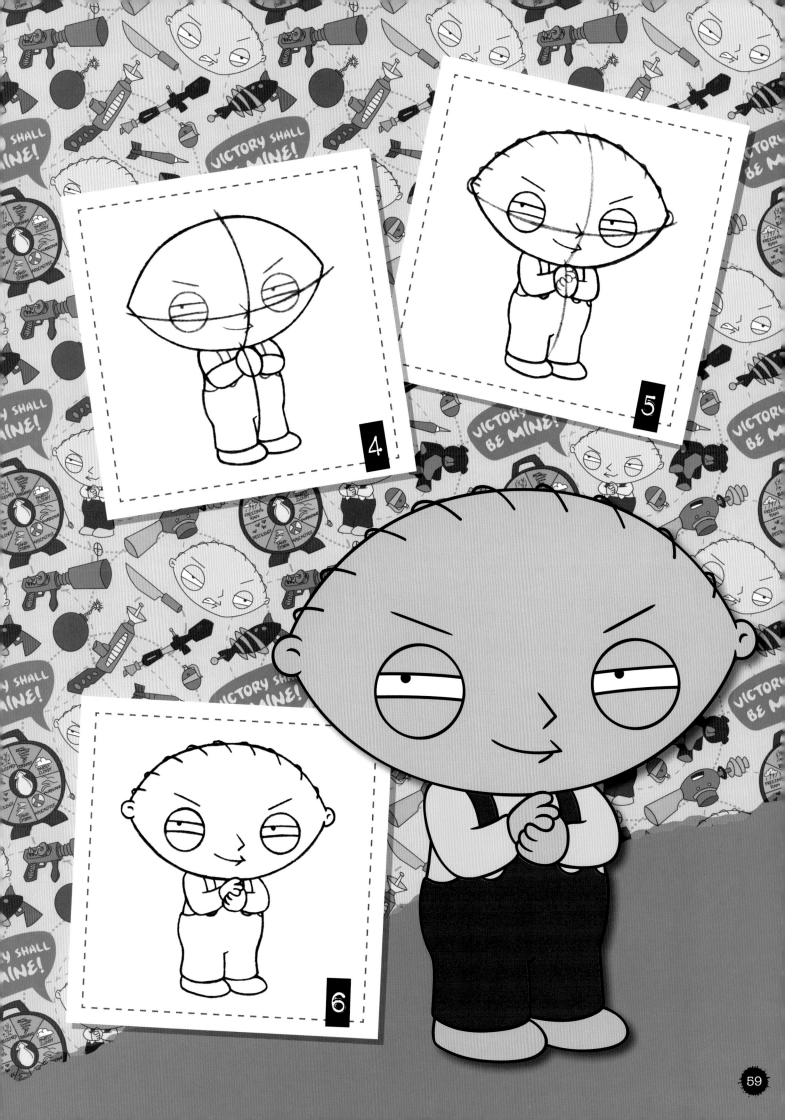

"OBEY ME OR I'LL PUT YOU ON DIAPER DETAIL!"

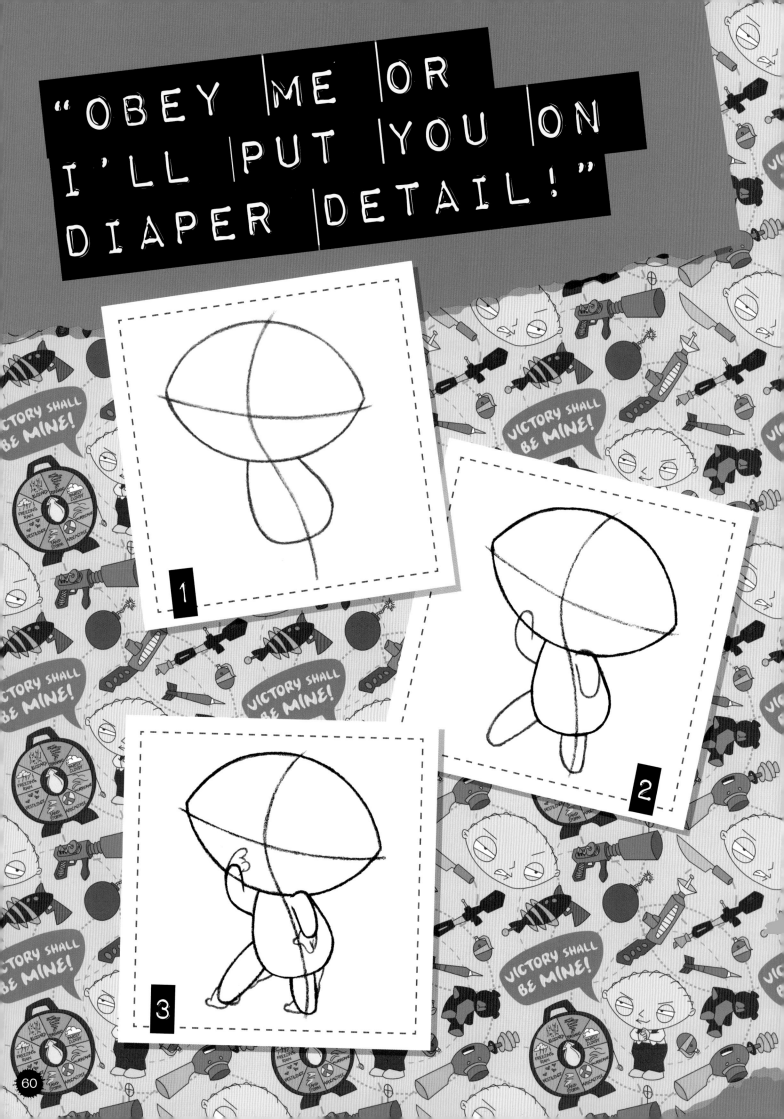

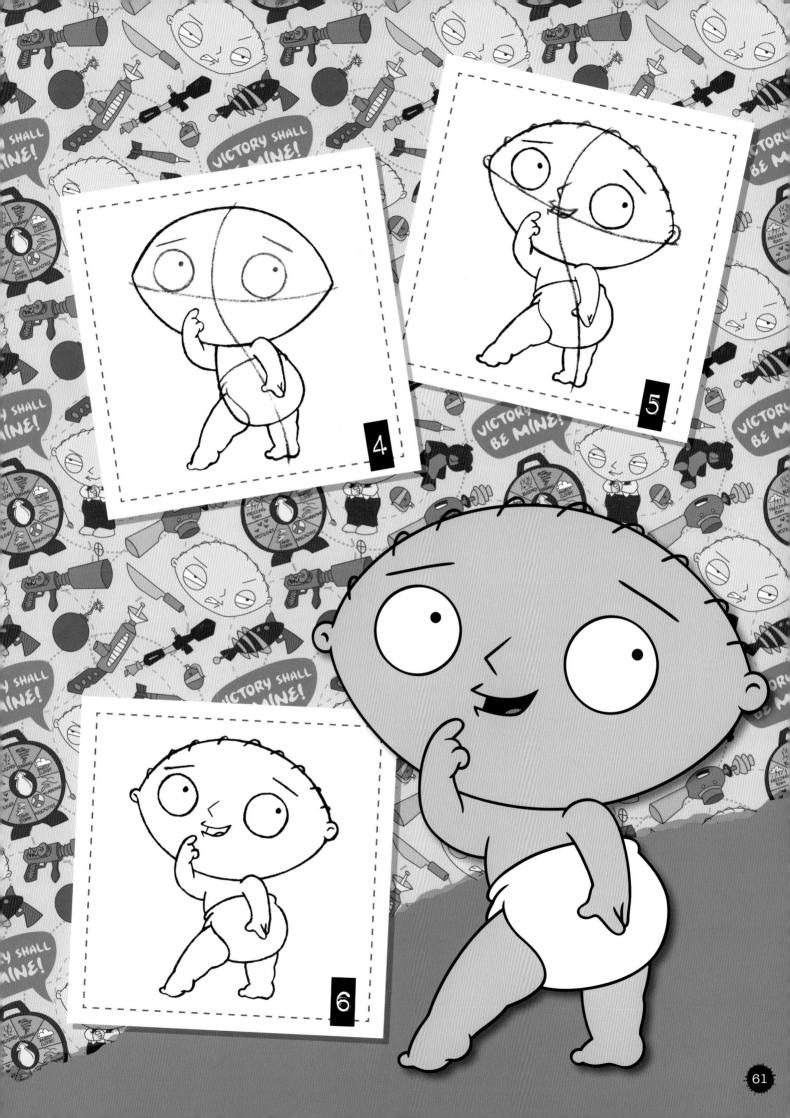

STEWIE & HIS EVIL TWIN BERTRAM

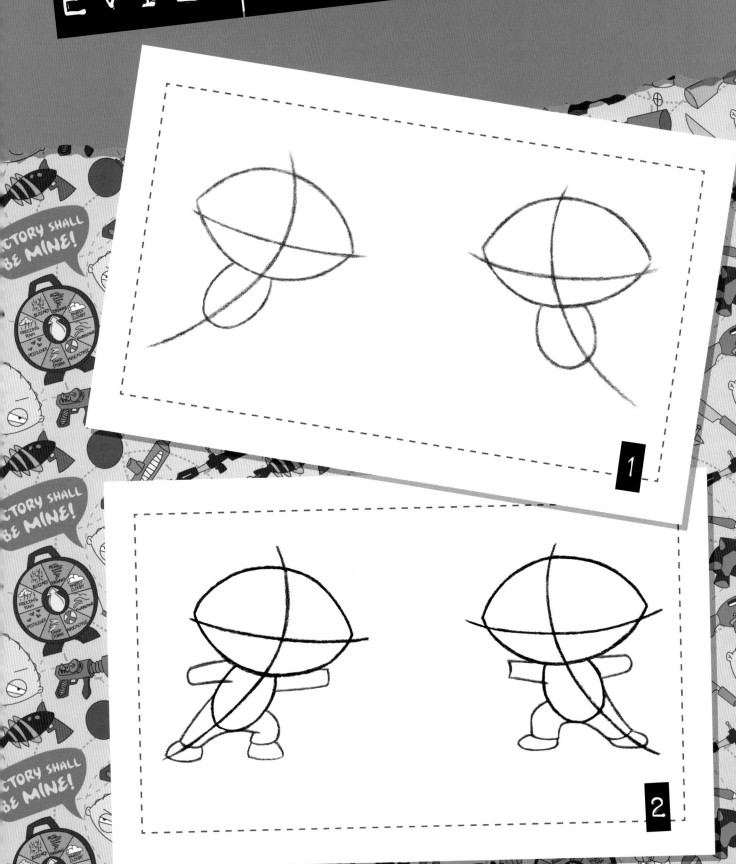

1

2

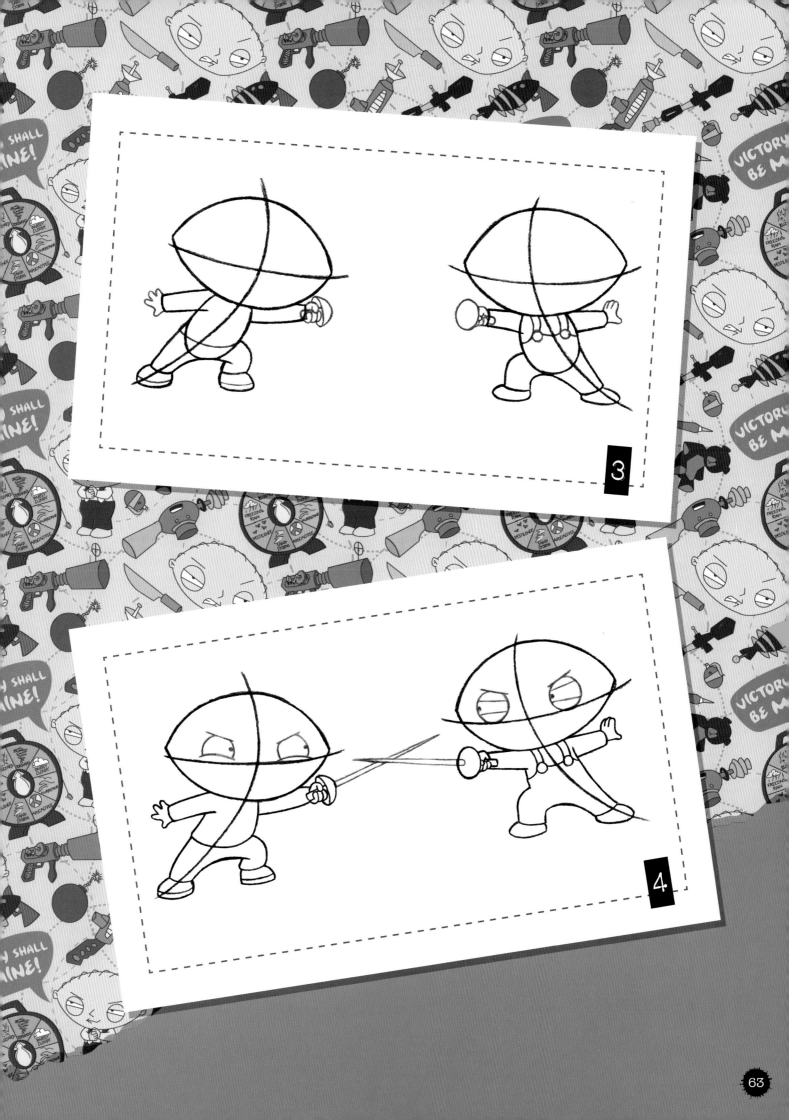

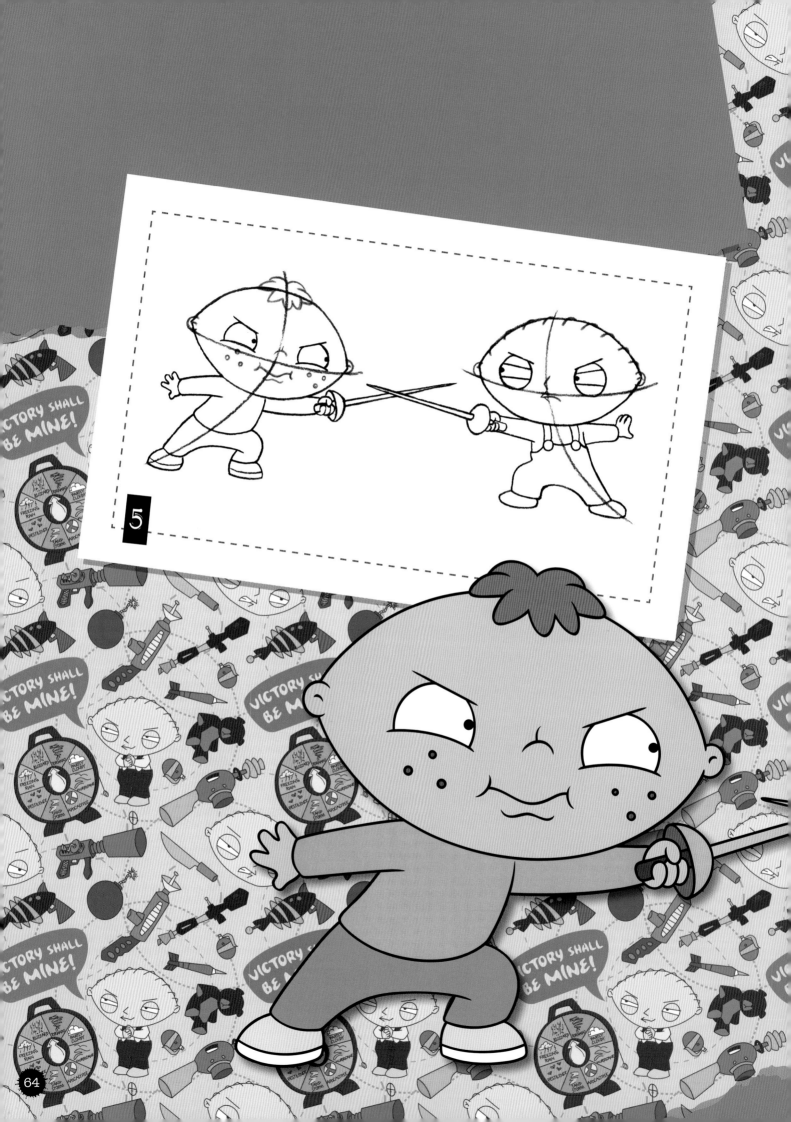

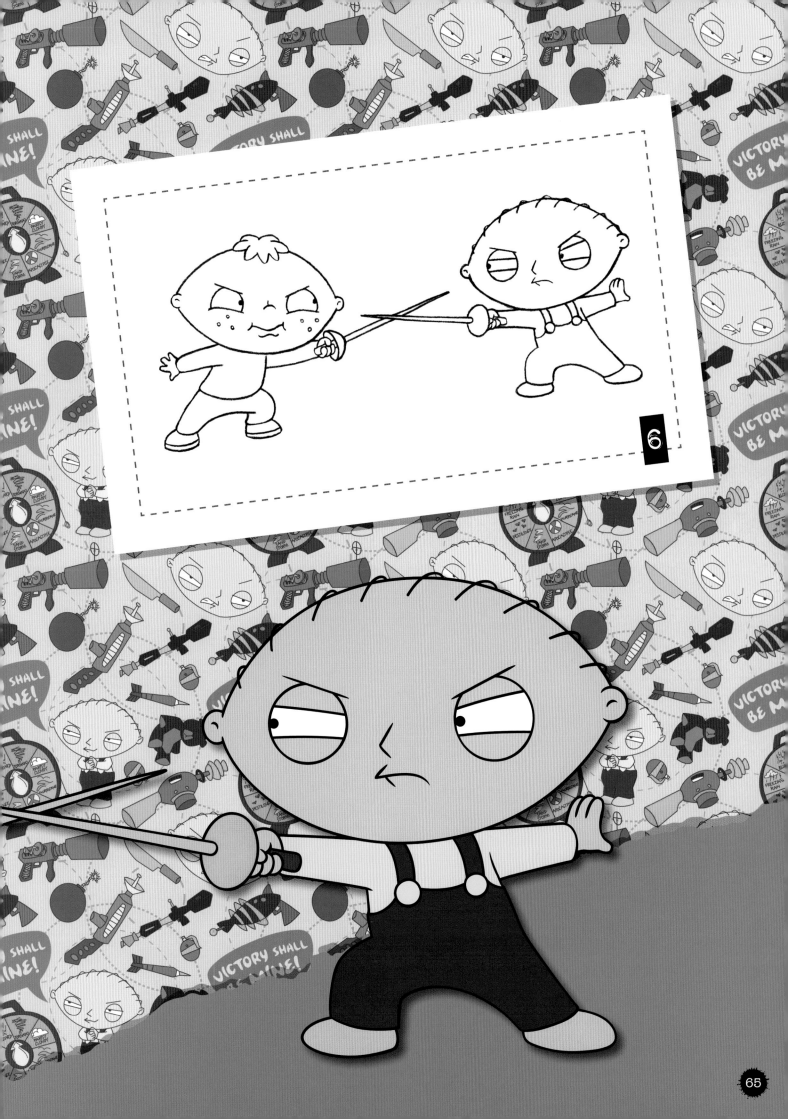

6

MORE STEWIE!

"Fie on you"

"Victory shall be mine!"

"The outrages I have suffered today will not be soon forgotten!"

BRIAN

THAT FEELS SO GOOD! THAT FEELS SO GOOD! THAT FEELS SO GOOD!

Brian is more than just the family dog. As the adopted member of the Griffin family, before Brian met Peter, he was a homeless stray who cleaned windshields for handouts. Now Brian is the first person Peter turns to in times of crisis. From witty bon mots to sarcastic barbs, Brian has an answer for everything.

Brian is a gentleman and a scholar and is undeniably the most eloquent member of the Griffin household. He even went to college before he became the family dog, though he failed to graduate. Brian has literary aspirations and a yearning for love. He adores opera and jazz, has liberal politics, is a staunch atheist, and is a member of Mensa.

Brian has shown exasperation at being unable to find a woman as cultured as himself, although he usually just goes for looks. Even the great love of his life would probably get dumped if Brian could get his hands on Lois. His attraction to the Griffin matriarch is barely under the surface.

Brian's had more than his fair share of problems with alcohol. He is also a recovered cocaine addict, after getting rather too enamored with the substance during a brief period as a police sniffer dog.

STOP YANKIN' MY CHAIN!

"Do you Mind?"

69

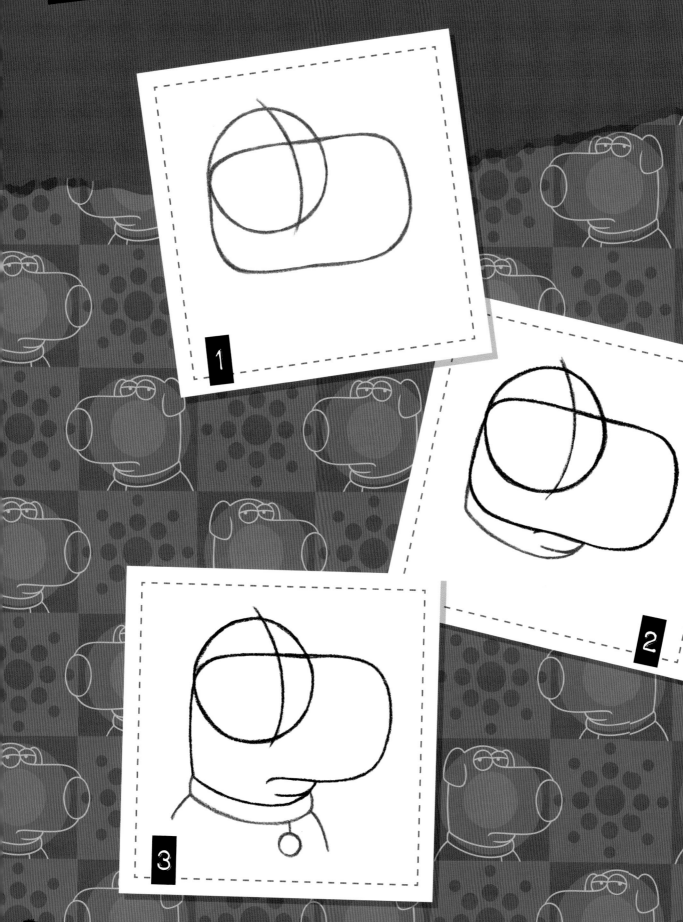

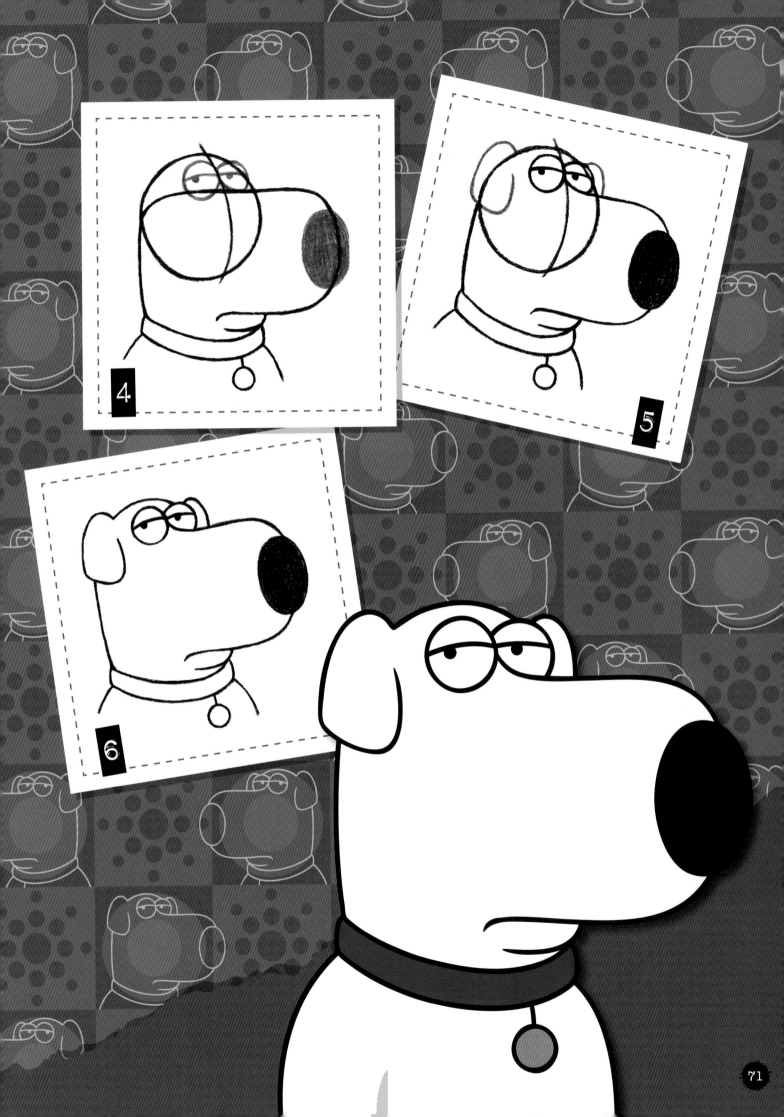

4

5

6

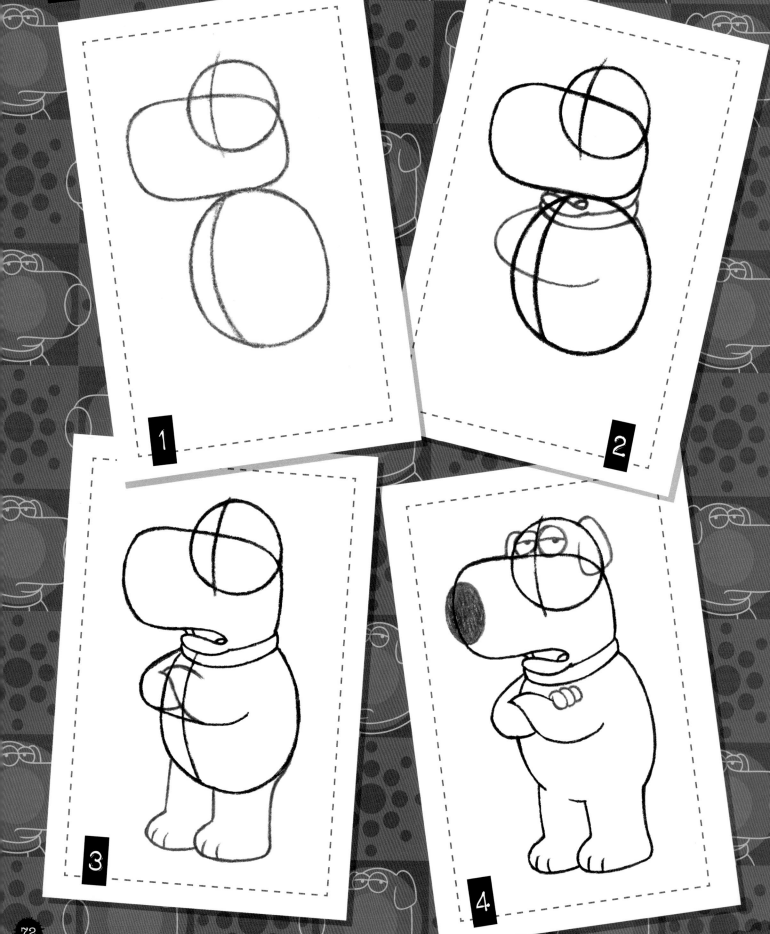

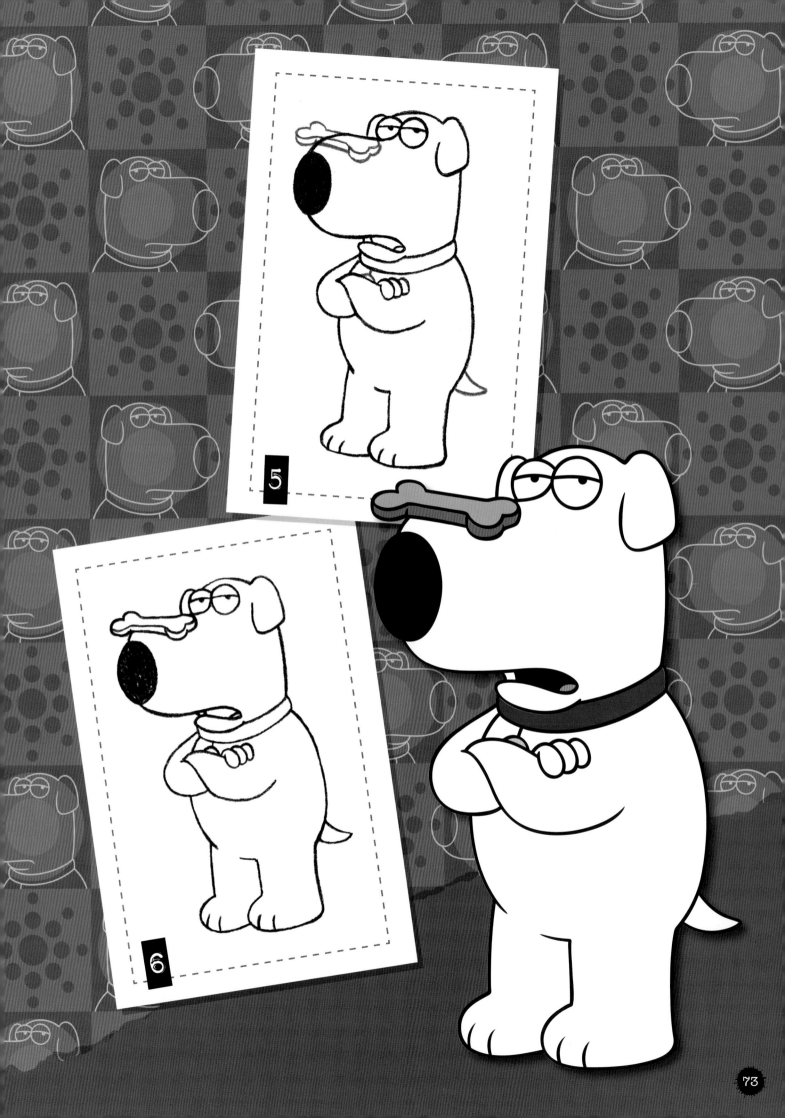

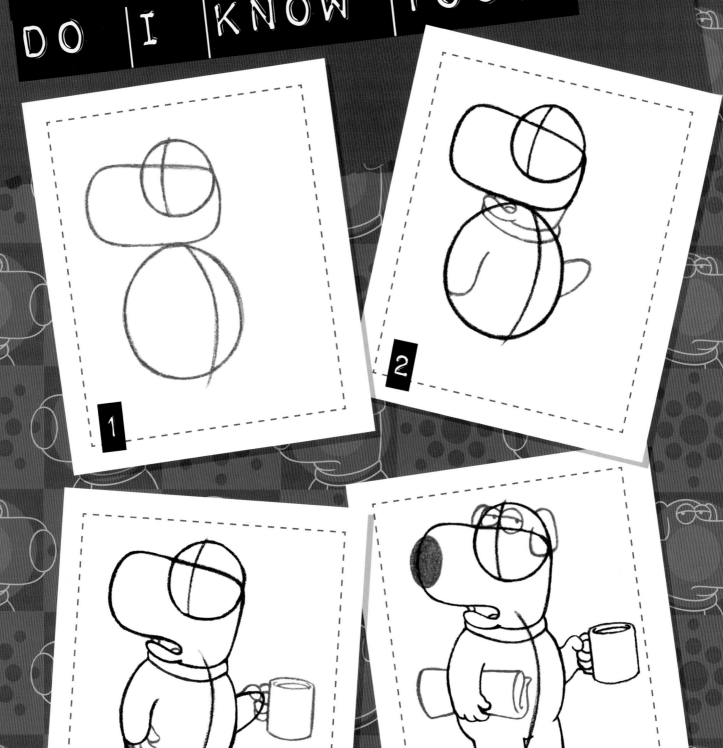

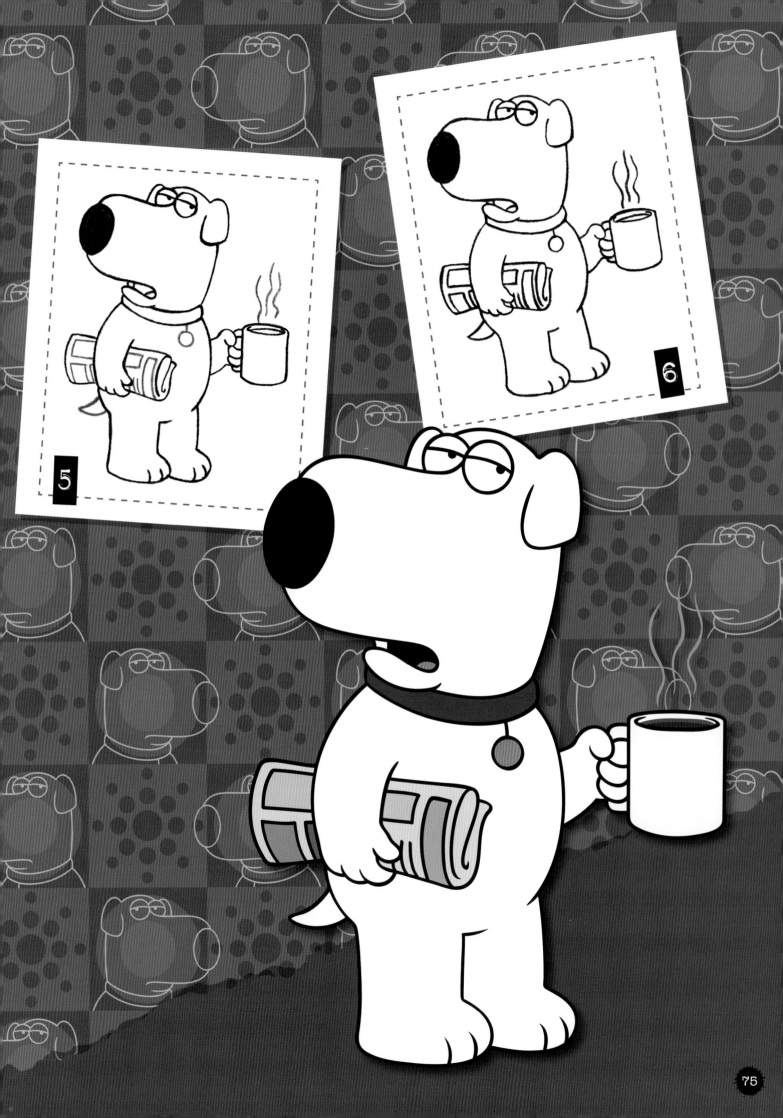

MORE BRIAN!

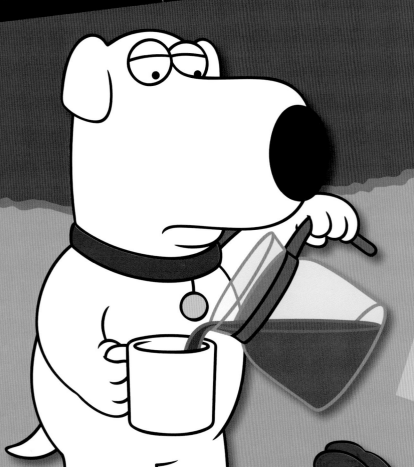

"Don't make me beg."

"I leave more personality in tightly coiled piles on the lawn."

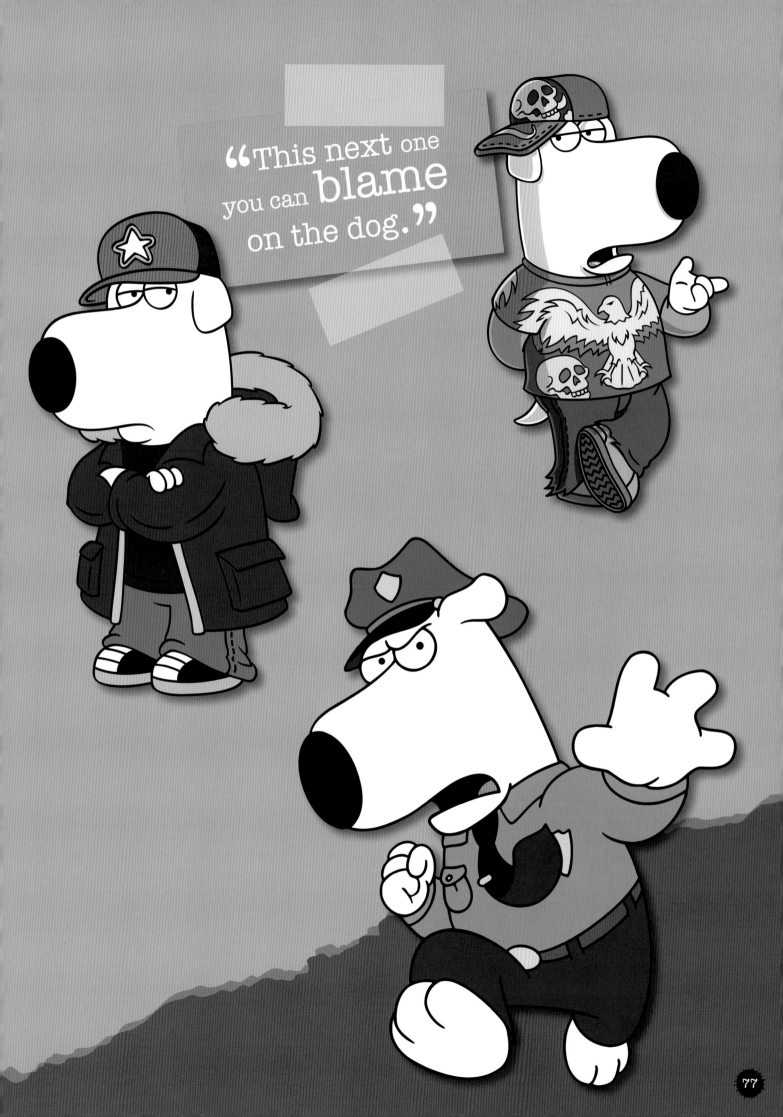

"This next one you can blame on the dog."

PETER & THE GIANT CHICKEN

Chickens are cute, right? All feathery, clucky, and egg-laying. Well, not if they're more than 6 feet tall and a ball of barely covered fury, prepared to keep a fight going for years and never letting the grudge go! That is the life of The Giant Chicken, an enormous avian who really needs anger-management classes.

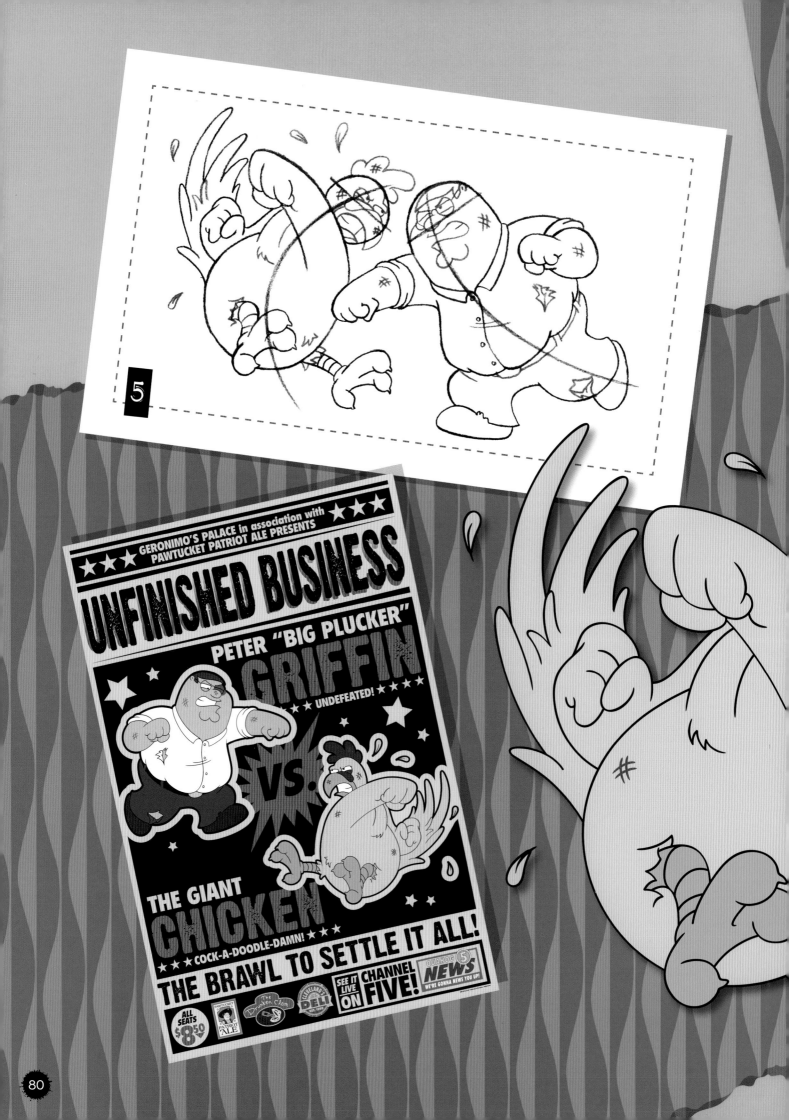

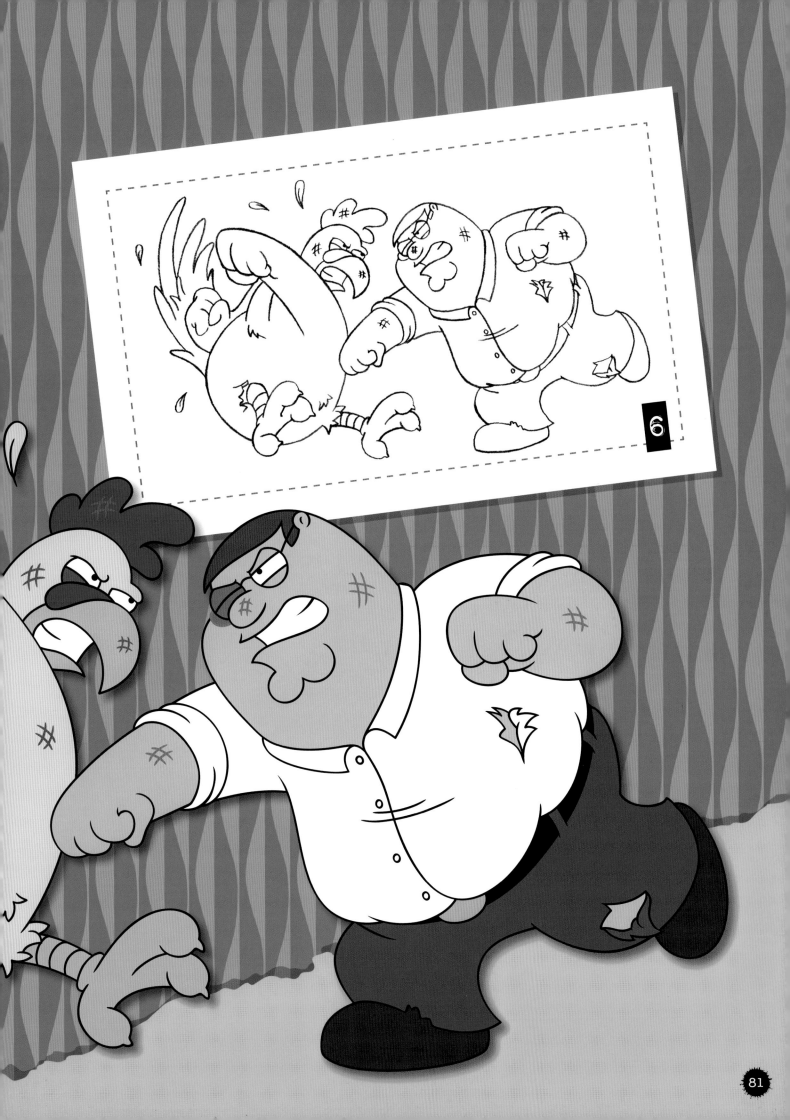

STEWIE & BRIAN

In the Griffin household, these two are cohorts in all sorts of schemes and the best of buddies—most of the time. Brian is the only family member who actually understands what Stewie is trying to say. Bonded over a mutual disdain for the stupidity of others, conflict for the duo usually finds a way of working itself out.

1

2

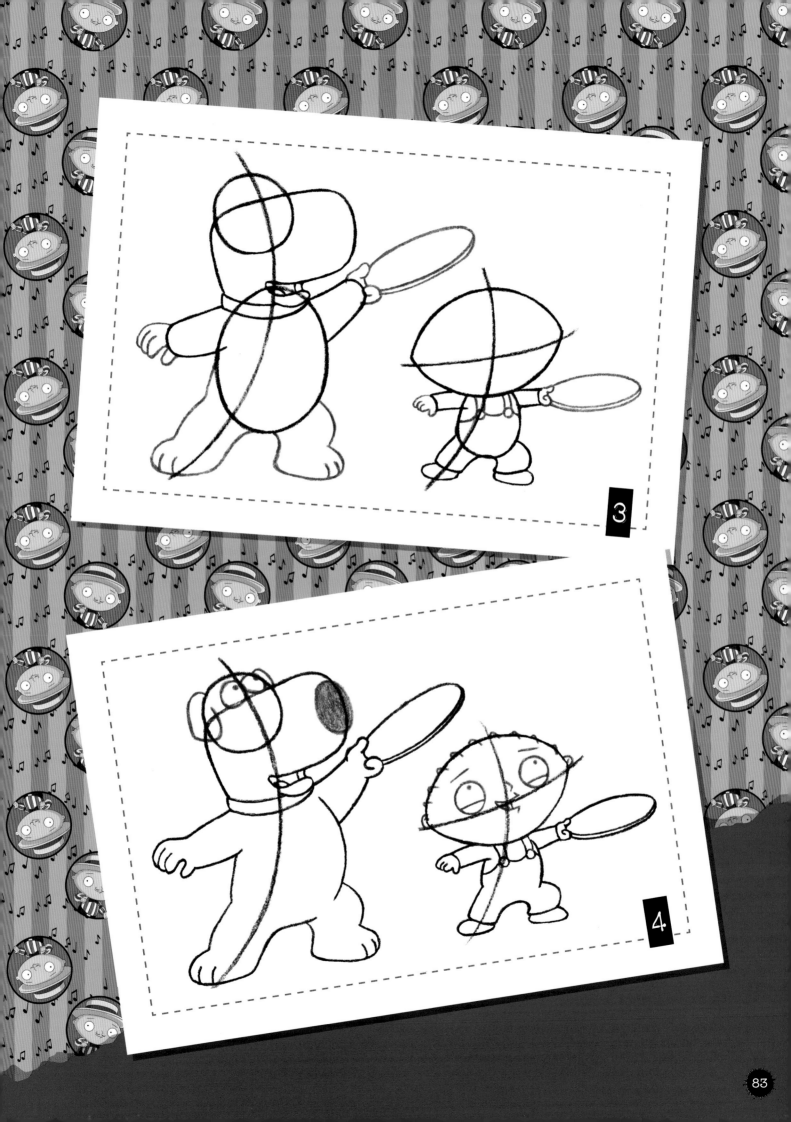

3

4

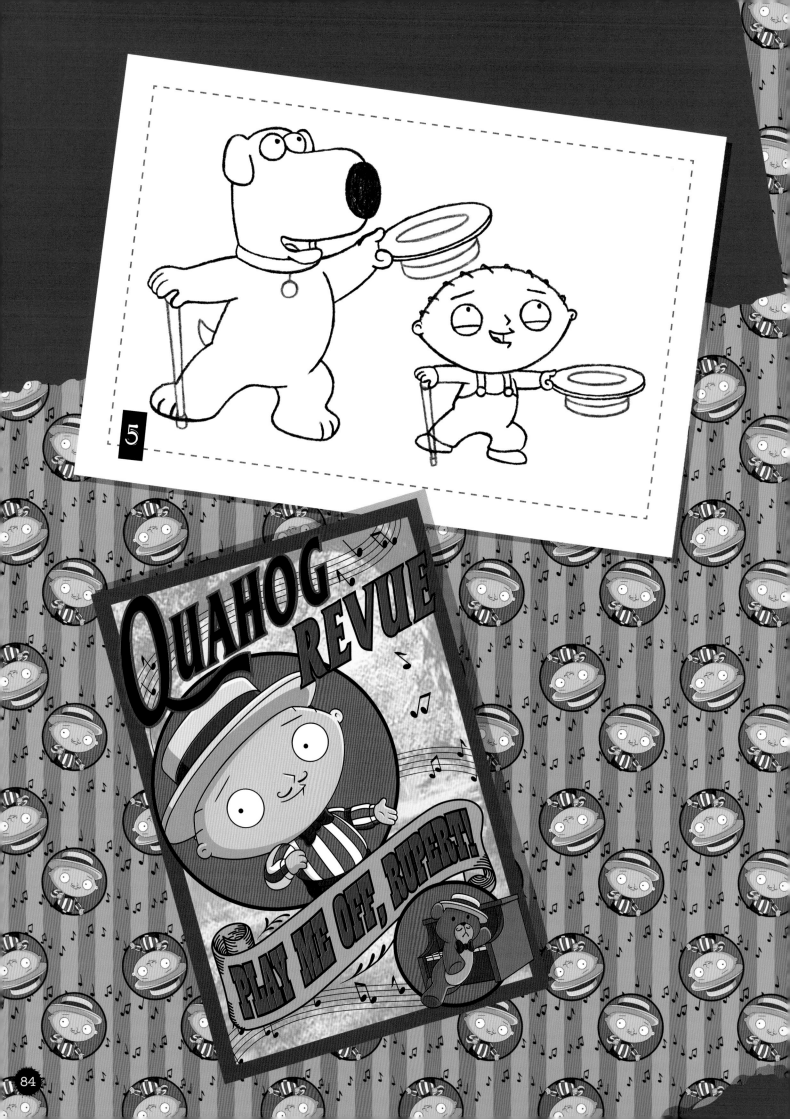

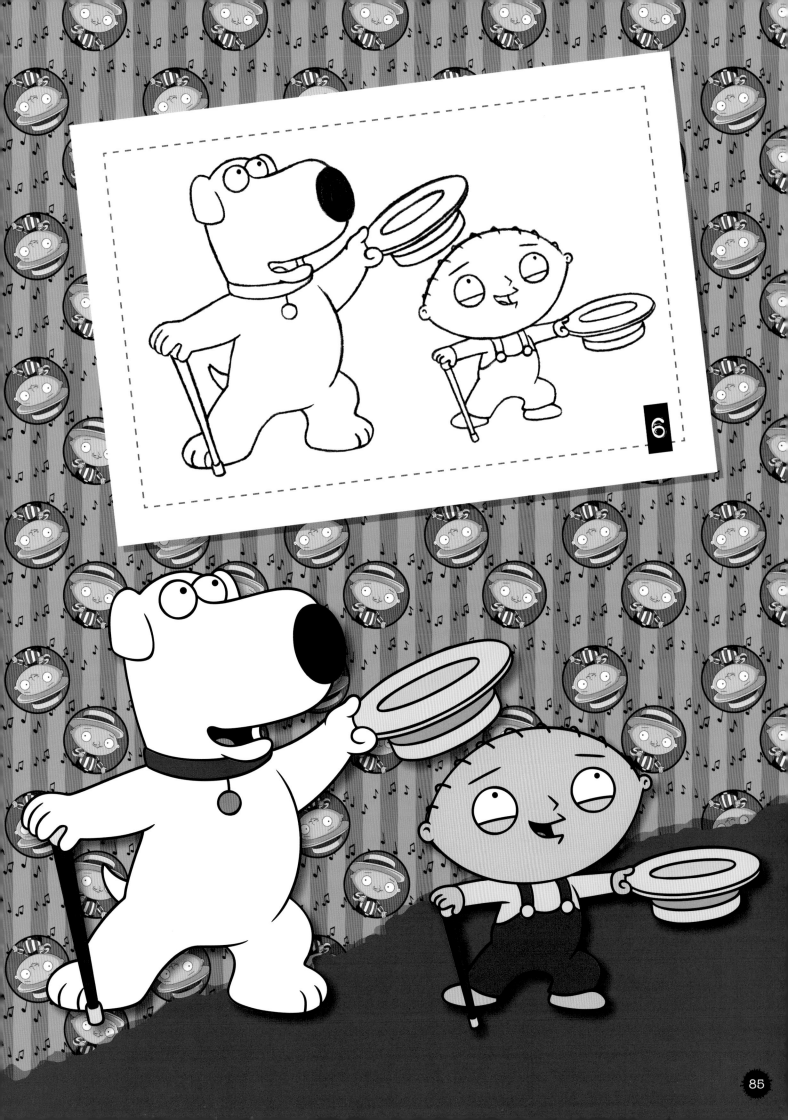

LOIS & BRIAN

No matter how enamored Brian is with Lois, she insists on treating him like the family dog. Rather than finding his affections acknowledged and returned, Brian typically finds himself on the receiving end of a scene just like this.

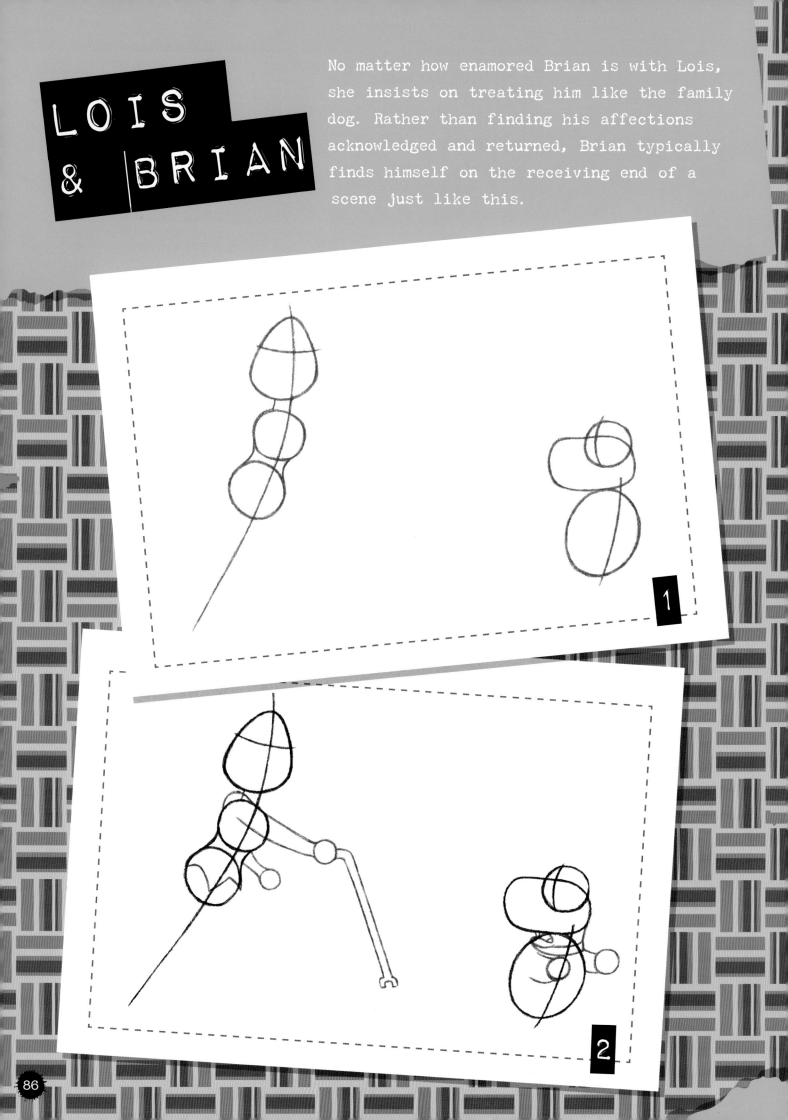

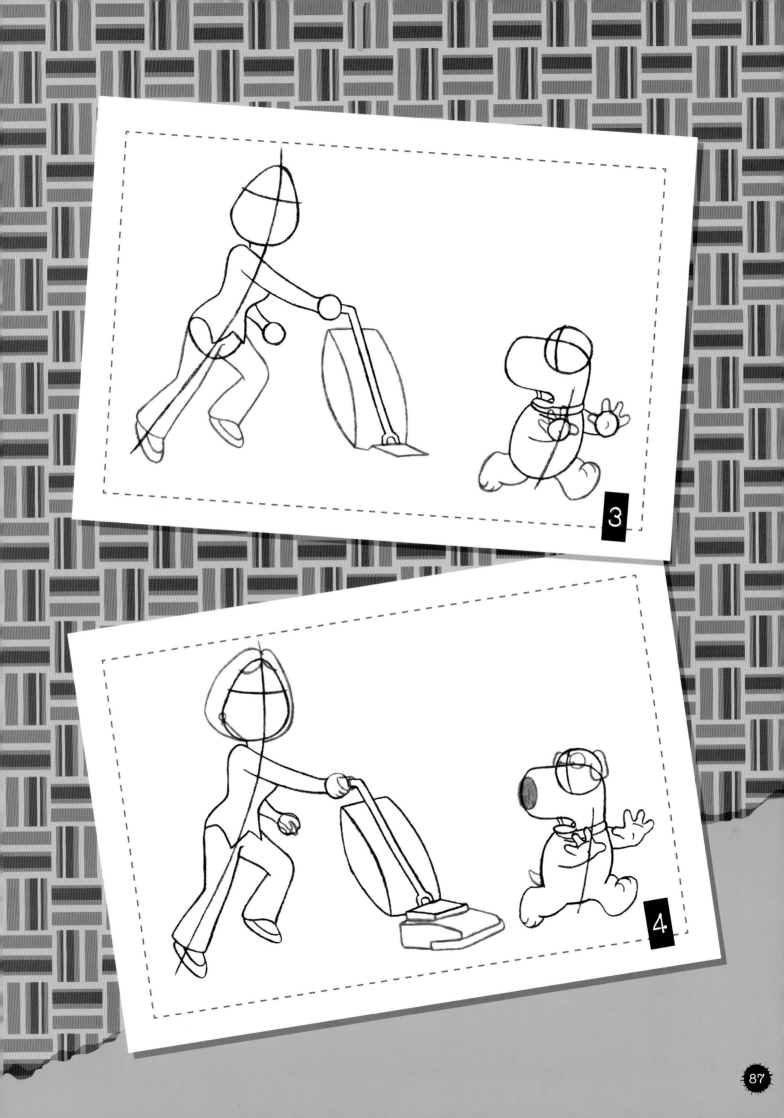

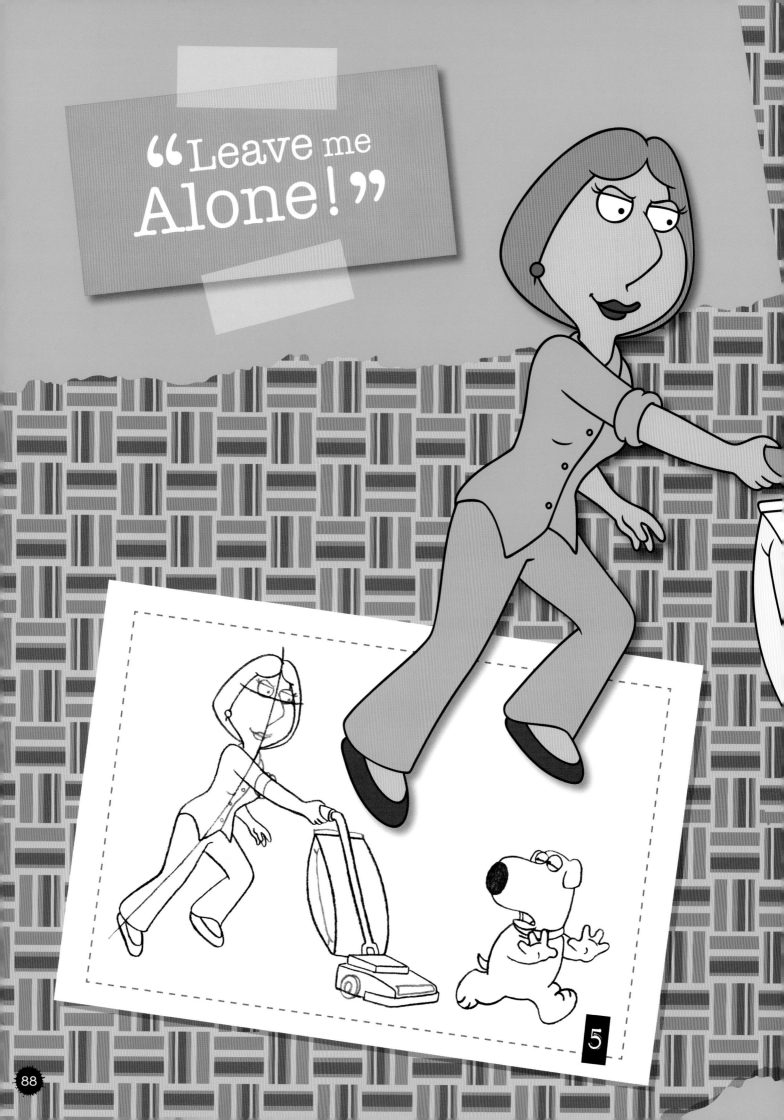

"Leave me Alone!"

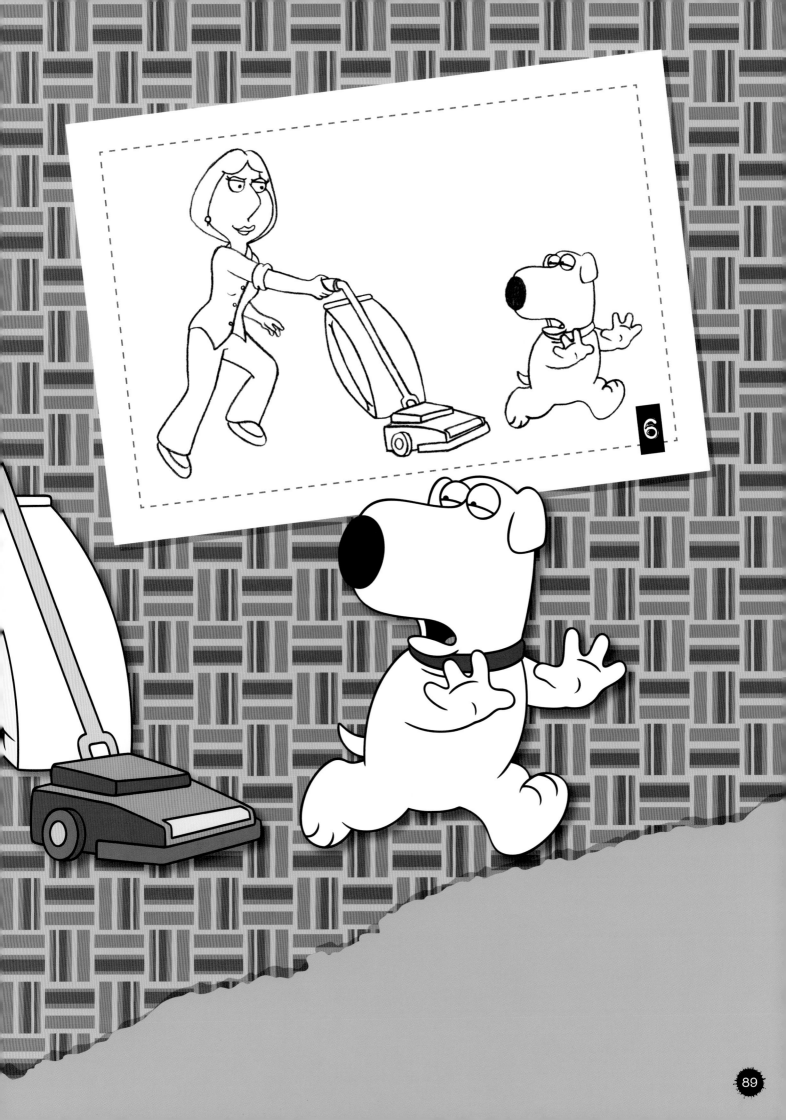

PETER, BRIAN & STEWIE

Elaborate musical numbers from Peter, Brian, and Stewie are some of the most memorable moments on *Family Guy*. From extremely catchy classics such as "Prom Night Dumpster Baby" and "This House is Freakin' Sweet" to the perennial fan favorite "Shipoopi" and the award-winning "You Got a Lot to See," you can always rely on these three to break into spontaneous song and dance—sometimes at the most inappropriate of moments!

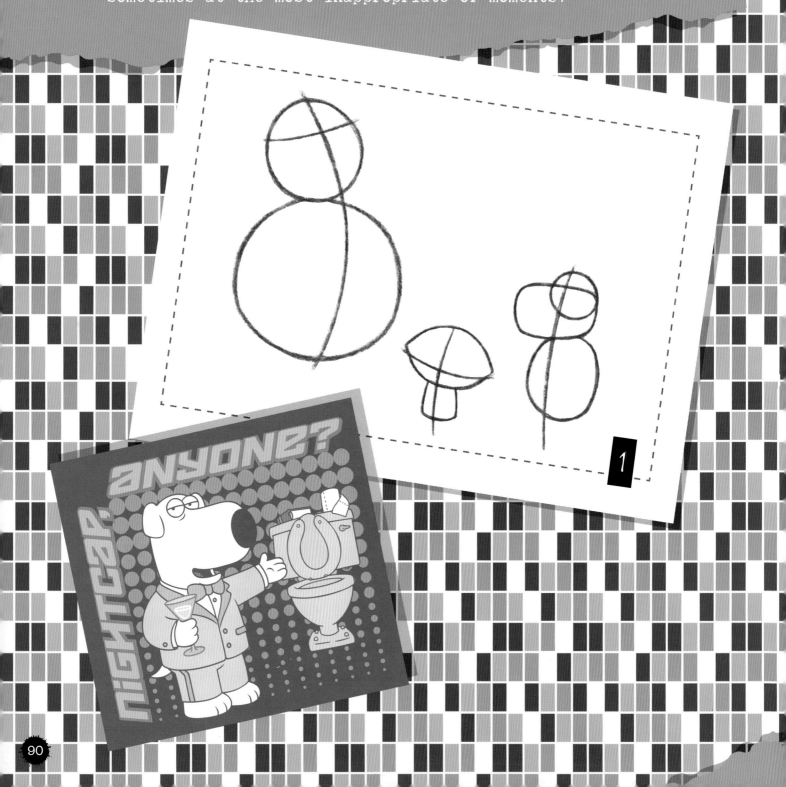

1

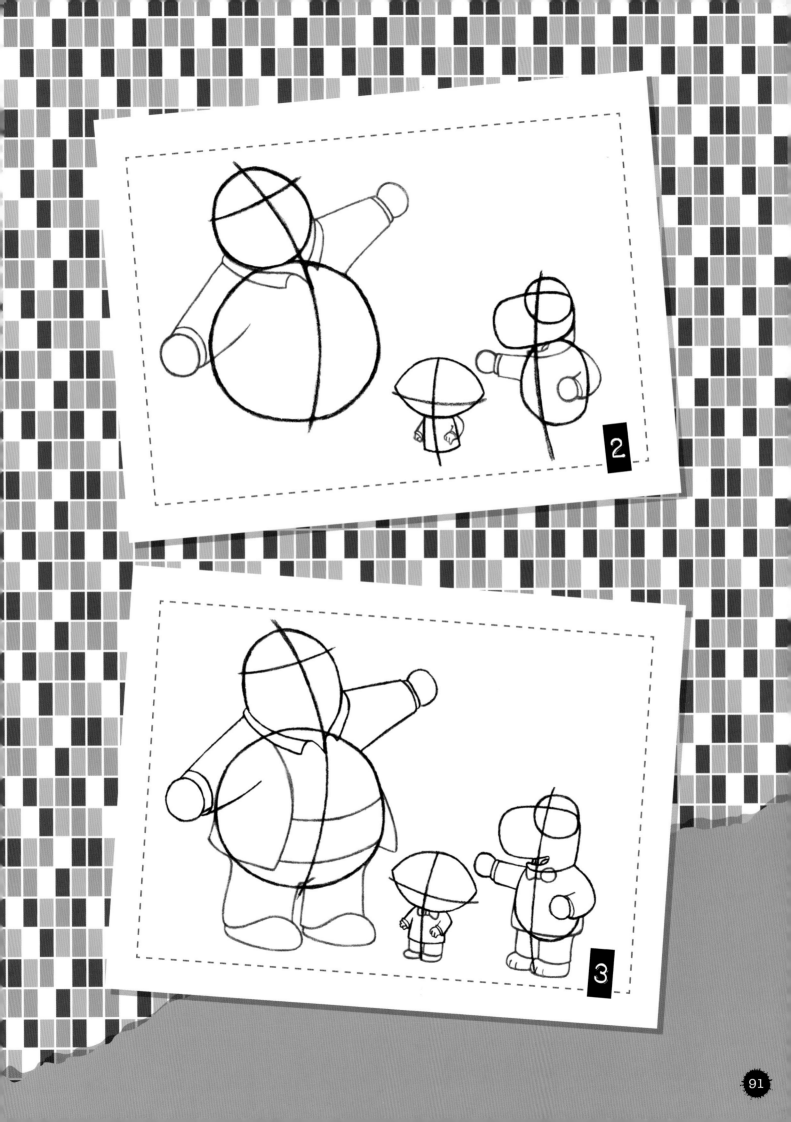

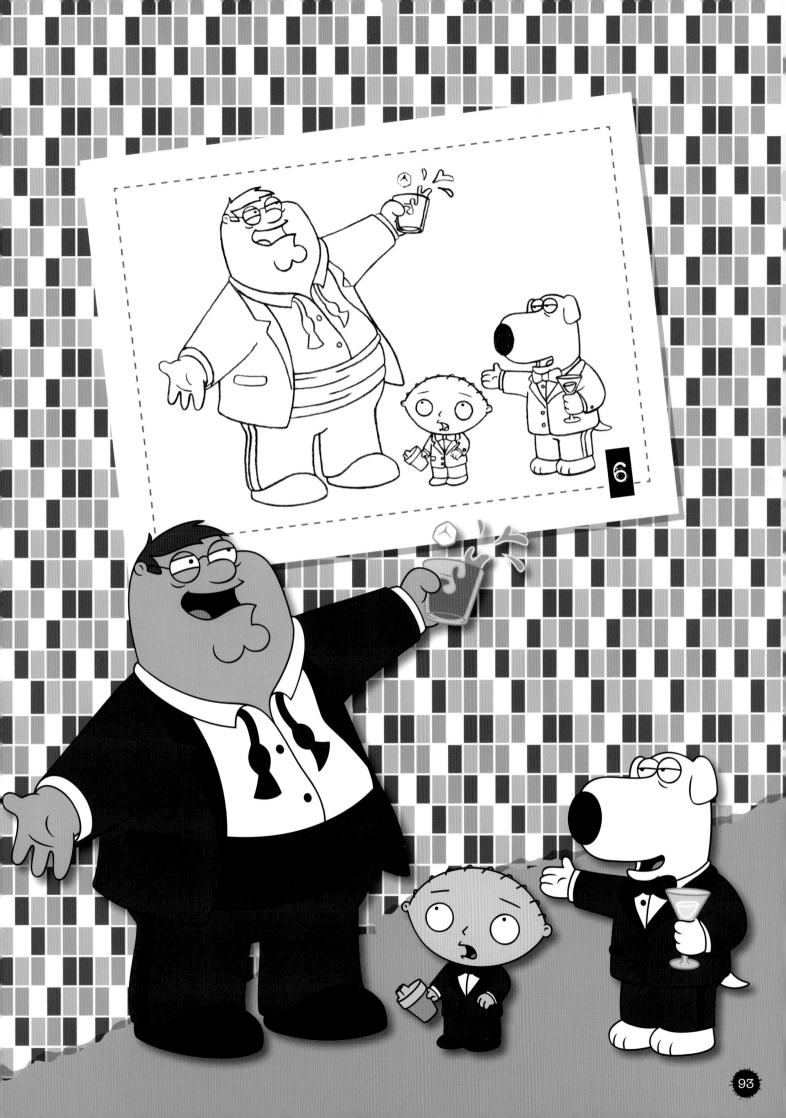

MORE GRIFFIN FAMILY!

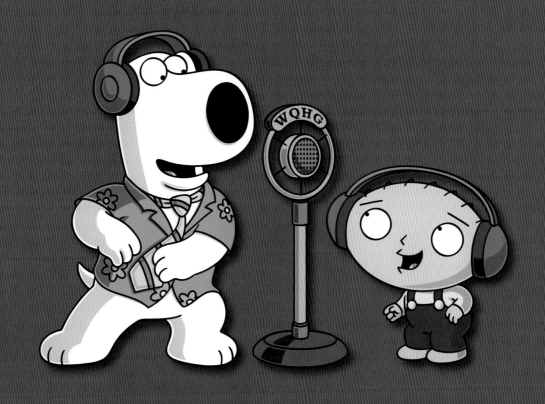

STEWIE & WORLD DOMINATION

Stewie Griffin is a maniacal baby genius completely obsessed with achieving world domination and turning absolute power over to himself.

Stewie's evil schemes know no bounds. His first plans for takeover predated even his own birth, when he left a ticking bomb and a map of Europe with plans to destroy its capitals inside of Lois's womb. Since then, armed with his teddy bear (and trusted confidant), Rupert, and his laser gun, Stewie has, on multiple occasions, almost singlehandedly taken over the world. There are more guns than stuffed animals in Stewie's room, and over the years he has gathered and created various weapons—everything from pistols and crossbows to futuristic laser guns, shrink rays, and time-travel pods! Stewie's mastery of physics, mechanical engineering, and firearms are at a level only matched by science fiction.

In everything he does, Stewie exhibits a fantastically acerbic perspective, honed from months of miscalculated matriarchal assassinations and attempts at world domination. Victory will be his!

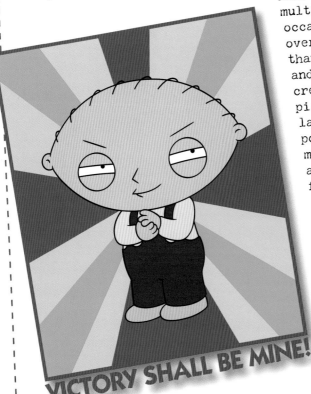

VICTORY SHALL BE MINE!

PETER & THE GIANT CHICKEN

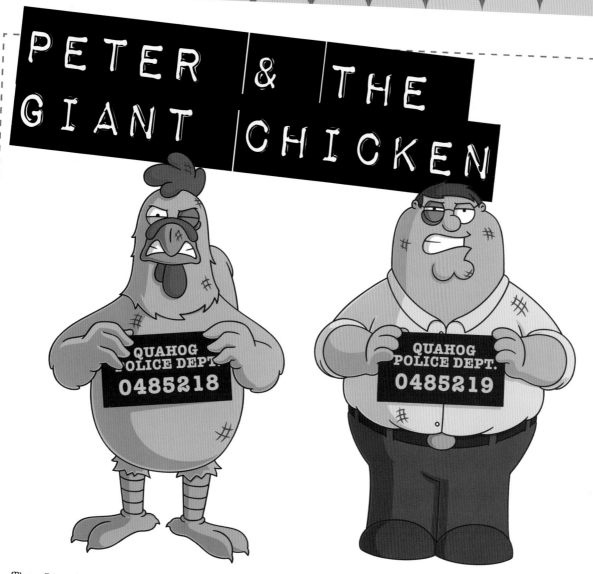

QUAHOG
POLICE DEPT.
0485218

QUAHOG
POLICE DEPT.
0485219

The Giant Chicken and Peter Griffin have a long history of violence. In the episode "Da Boom," it is explained during a flashback that their feud originated when The Giant Chicken gave Peter an expired coupon and Peter felt justifiably provoked to attack him. Since then, The Giant Chicken often appears at random and interrupts whatever Peter is doing. The two then inevitably engage in prolonged epic fistfights that can take place anywhere from sewers and subways to ferris wheels and trains. Always a drawn-out ordeal, their fights tend to cause mass destruction to everything around them, not to mention heavy casualties to any unfortunate bystanders.

However, Peter always wins the battles, and then proceeds to pick up where he left off and return to his former activity, battered and bruised. He is unaware that The Giant Chicken, having been left for dead, always awakens and gets up, promising yet another future fight.

QUAHOGIANS

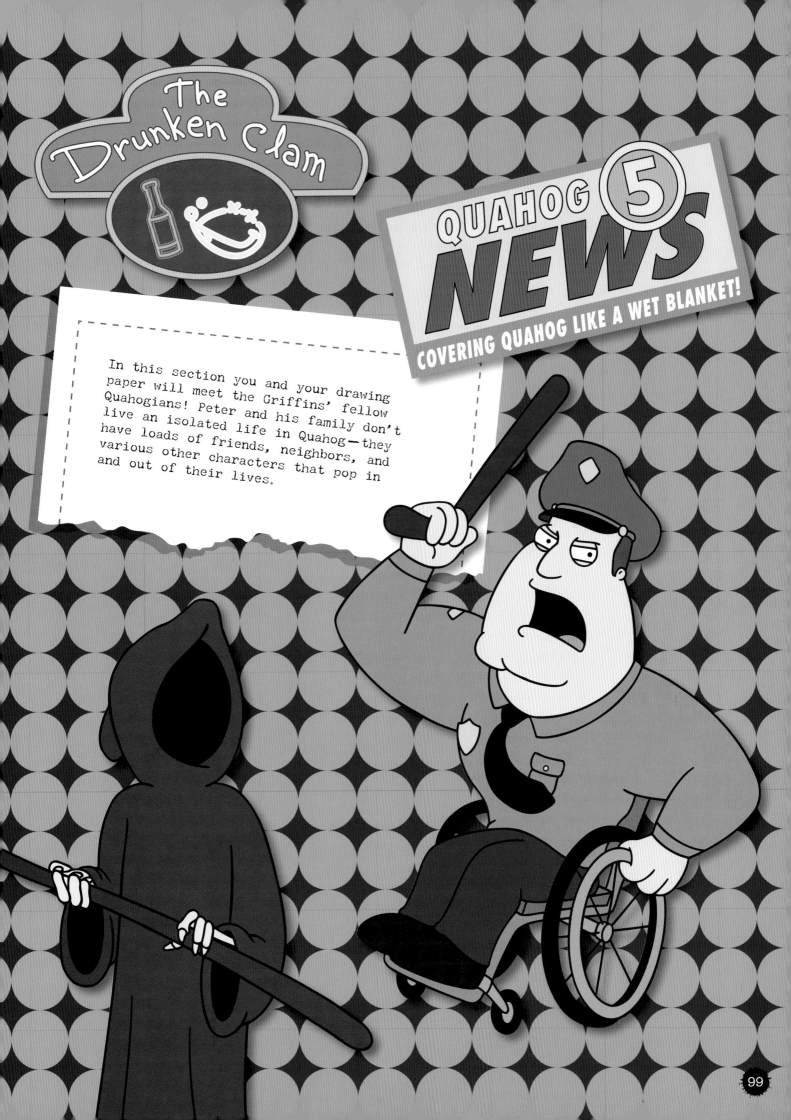

The Drunken Clam

QUAHOG 5 NEWS

COVERING QUAHOG LIKE A WET BLANKET!

In this section you and your drawing paper will meet the Griffins' fellow Quahogians! Peter and his family don't live an isolated life in Quahog—they have loads of friends, neighbors, and various other characters that pop in and out of their lives.

CLEVELAND

A former neighbor of the Griffins—and one of Peter's drinking buddies—Cleveland Brown recently returned to Quahog after living in Stoolbend, Virginia, for a few years. He has a son named Cleveland Jr. with his ex-wife, Loretta, and two step-children, Rallo and Roberta, with his new wife, Donna. Polite and sensitive, Cleveland wouldn't hurt a fly. Also, he has the finest mustache that Quahog has ever known.

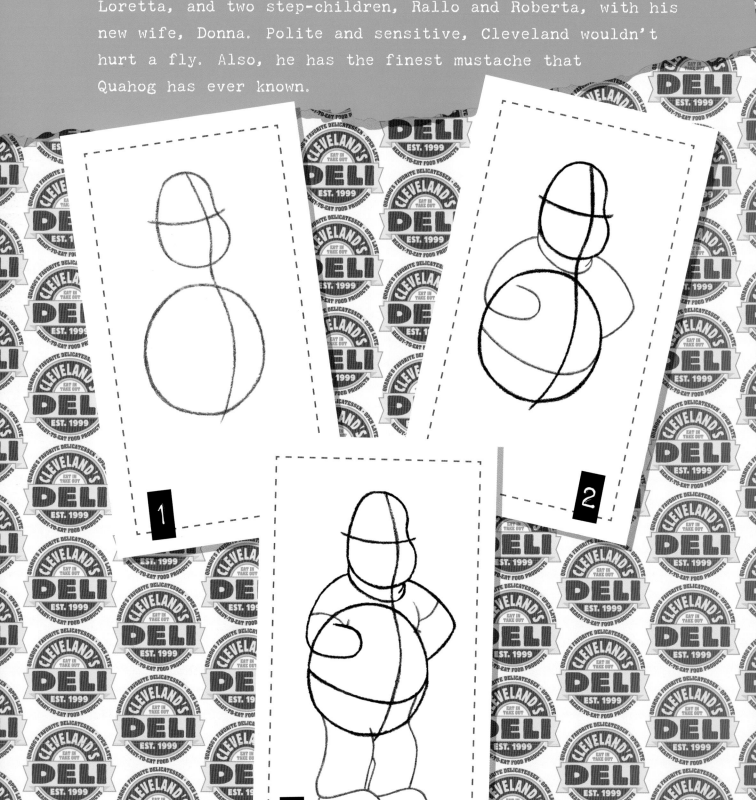

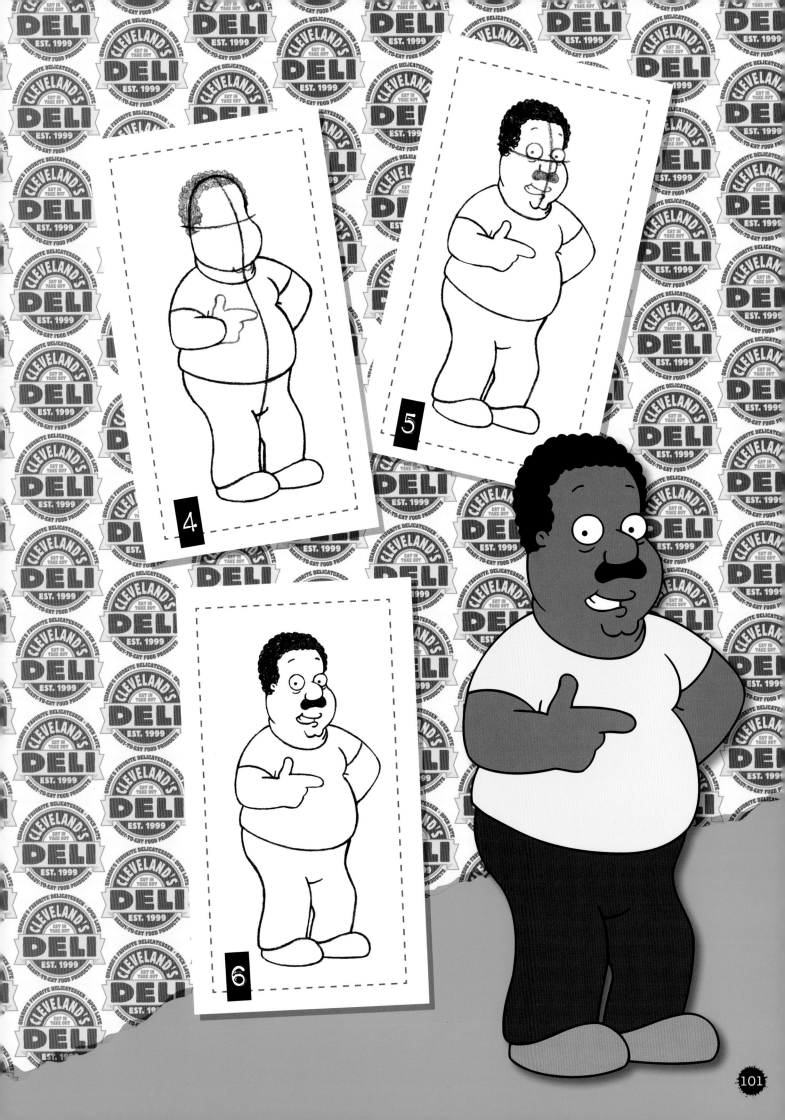

4.

5.

6.

JASPER

Jasper is a gay dog working as a dance teacher at Club Med. He is Brian Griffin's cousin and the two have a close relationship. Jasper lives in Los Angeles, is known for double entendres and camp innuendos, and enjoys dancing and club music. He also has a fiancé named Ricardo.

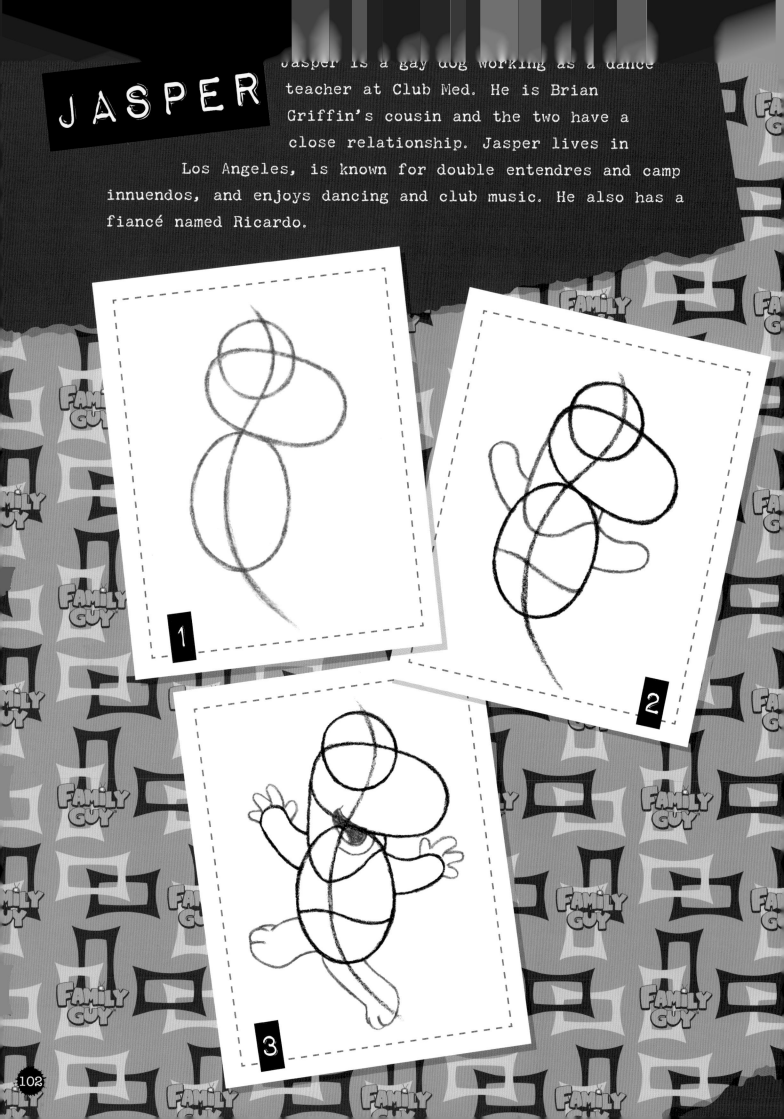

1

2

3

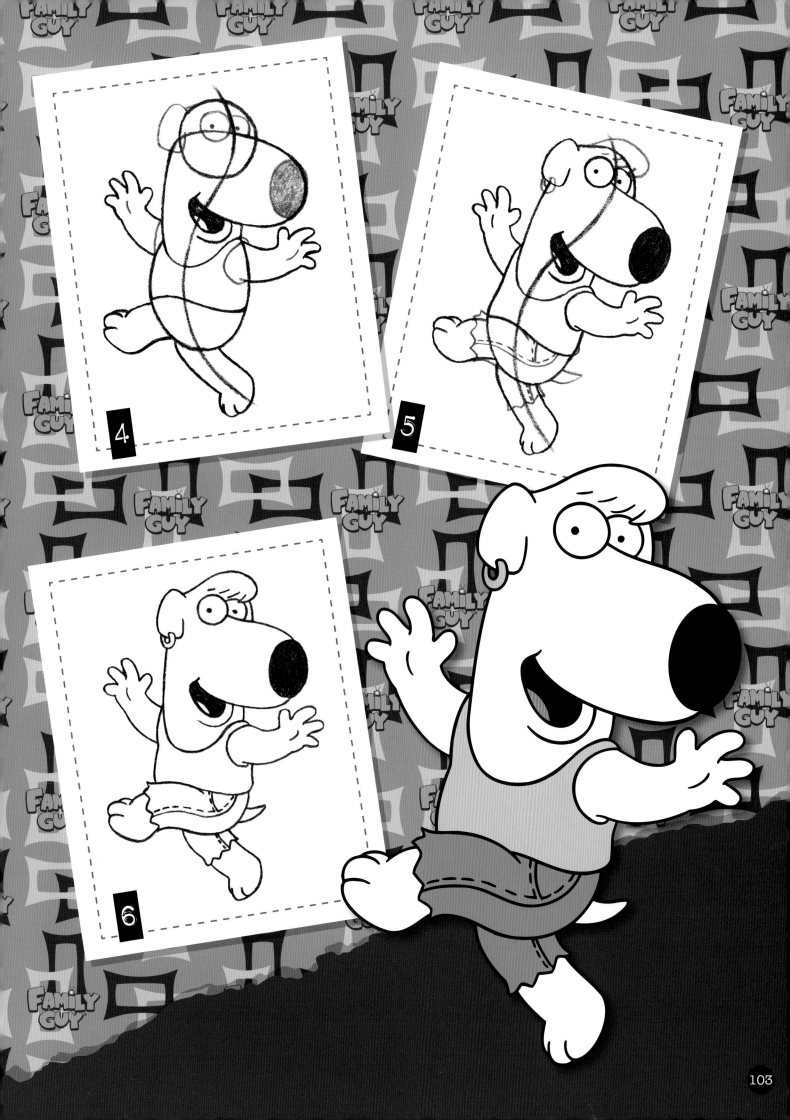

JOE SWANSON

Along with his wife, Bonnie, and daughter, Suzie, Joe Swanson is one of the Griffins' neighbors. Joe is disabled, having been paralyzed since trying to stop a Grinch-like creature from ruining Christmas, but he's still an active cop and able to put most people on two legs to shame. He sometimes gets down about his predicament, but generally he's the most positive person you can imagine. He does have a few anger issues, though, so don't push him too far!

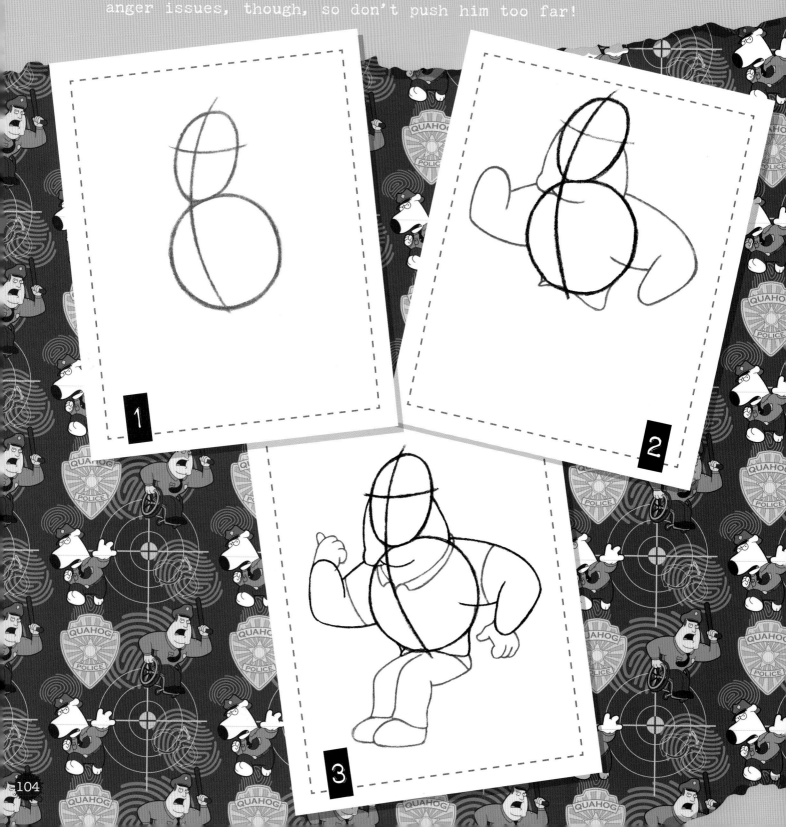

1

2

3

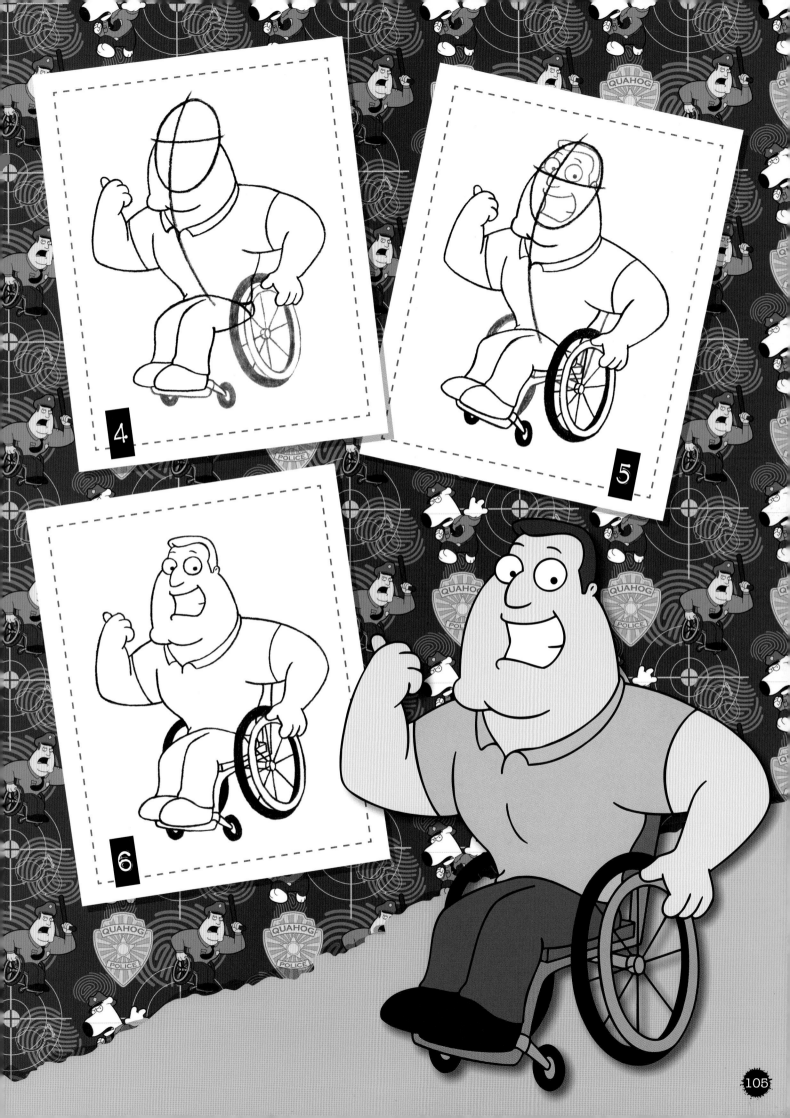

4

5

6

GREASED-UP DEAF GUY

Greased-Up Deaf Guy first appeared at the Happy-Go-Lucky Toy Factory company picnic, where one of the contests (Peter Griffin's favorite, of course) was to catch him after he was released from a cage and took off screaming in a high-pitched voice into the forest. Greased-Up Deaf Guy earned his unfortunate nickname the day he was late for a meeting and was caught in a grease truck explosion that burnt off his suit and rendered him deaf.

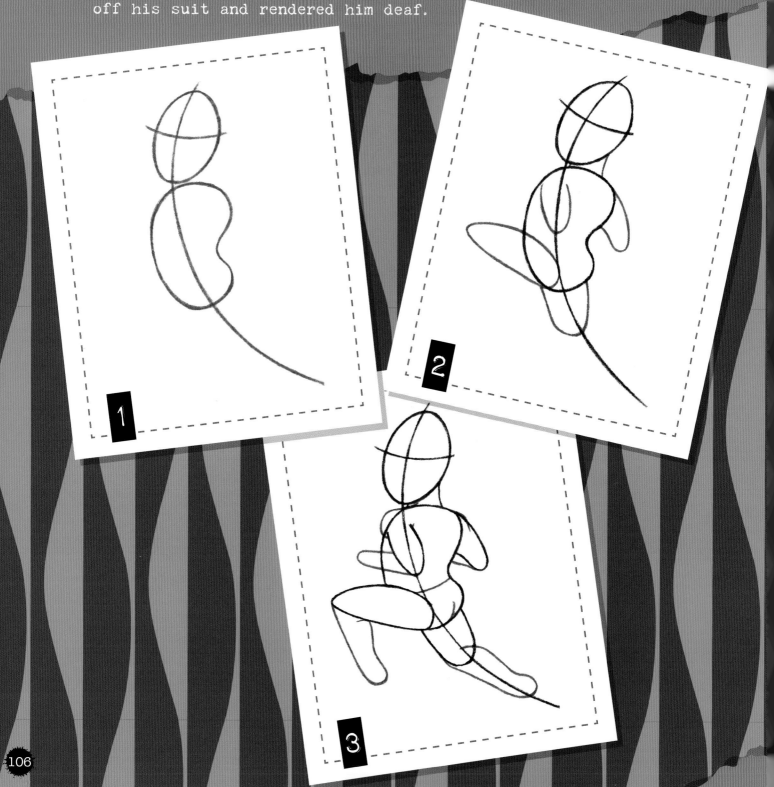

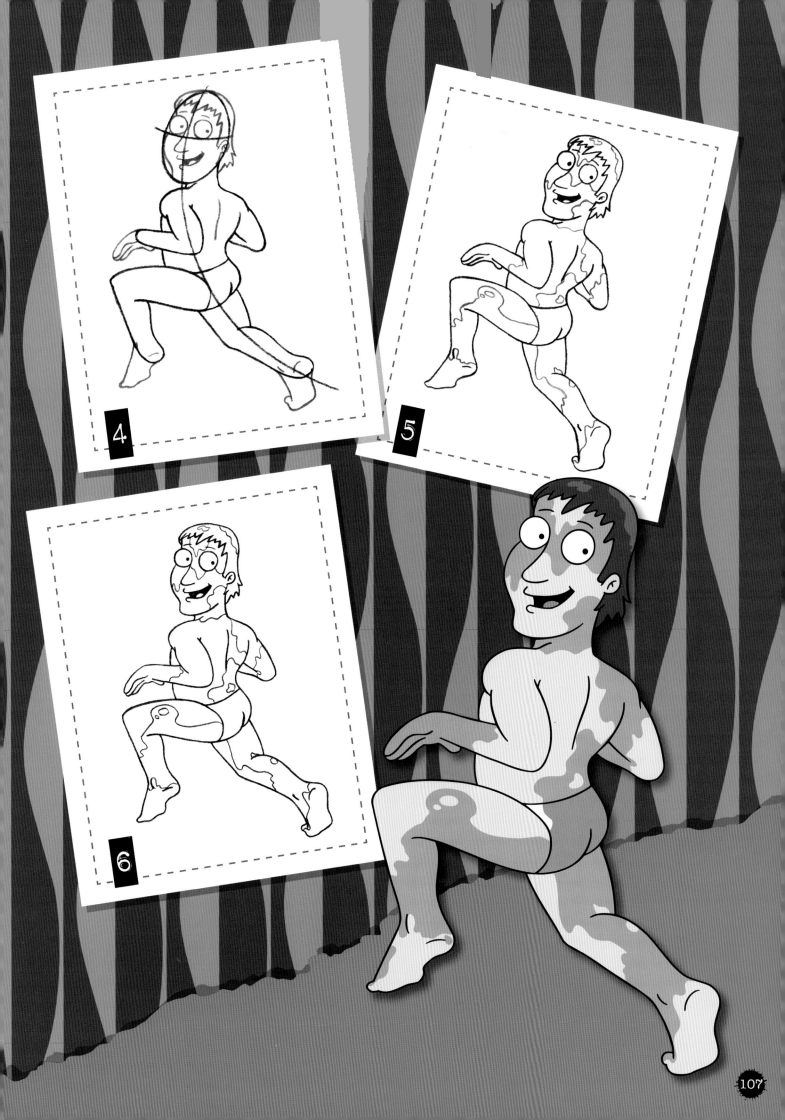

TRICIA TAKANAWA

Most of the on-the-spot current affairs news in Quahog comes from reporter Tricia Takanawa. She's a pretty fearless woman, prepared even to interview a mass murderer while he's escaping from jail just for a news report!

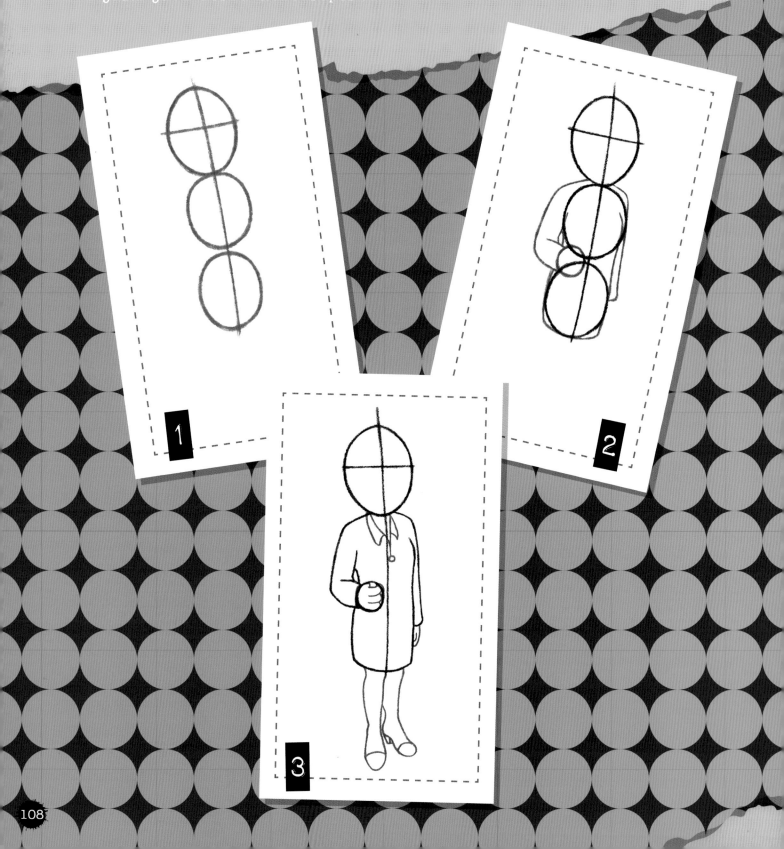

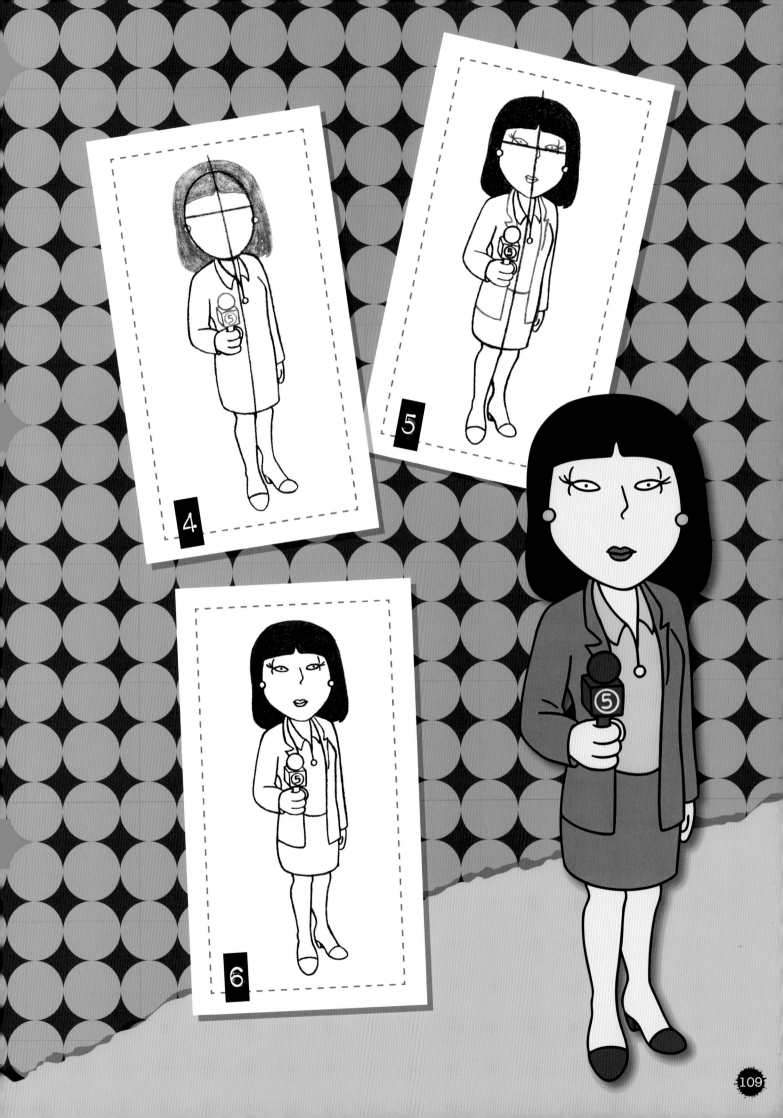

TOM TUCKER

Tom Tucker is anchorman of the Channel 5 Action News Team in Quahog. He is also the father of a deformed son named Jake, whose head is upside-down. Tom loves his mustache much more than any man should.

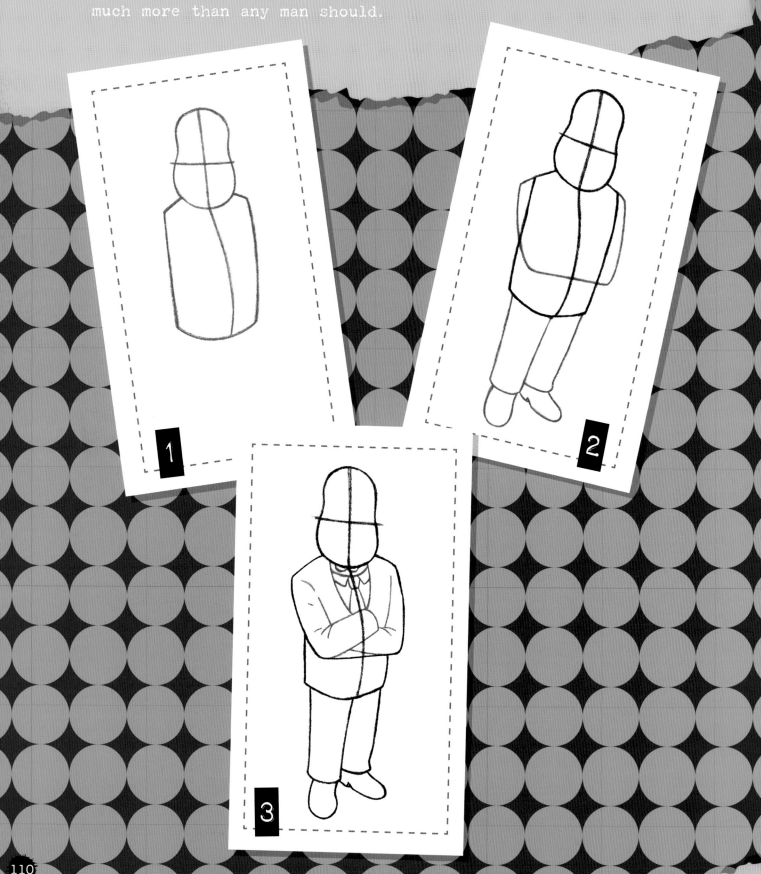

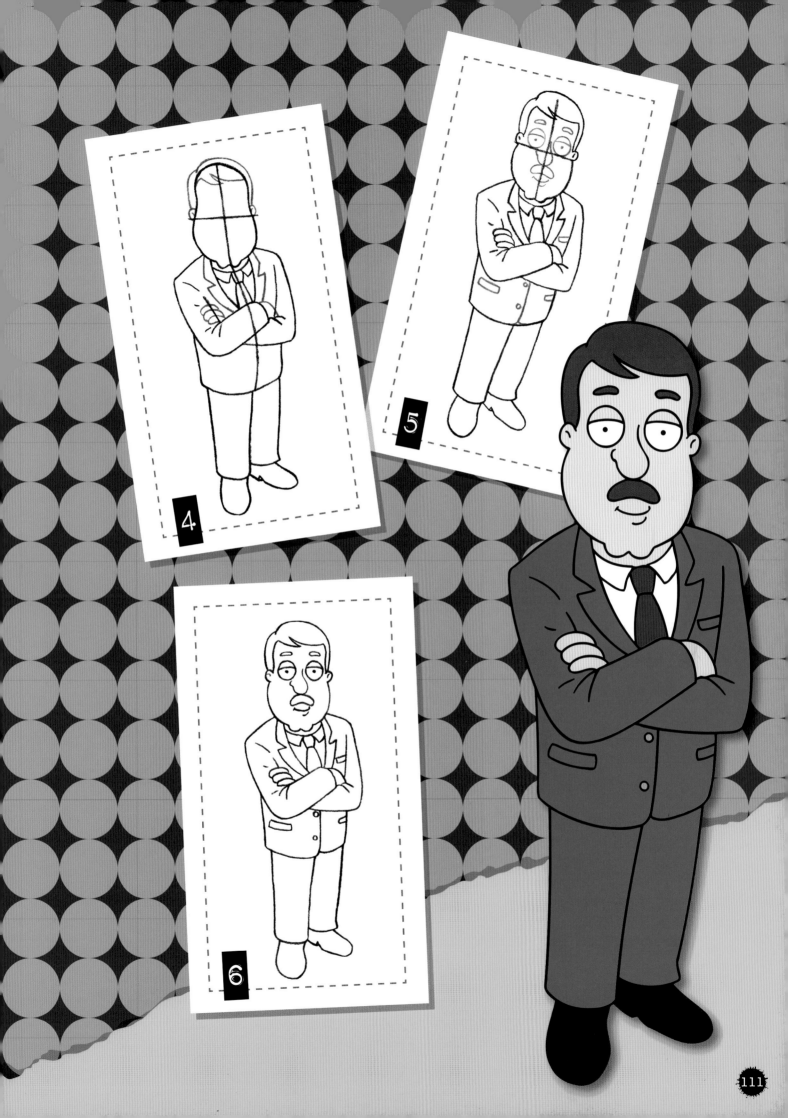

4

5

6

DEATH

The world of Family Guy isn't quite like the normal world. After all, it's unlikely any of us has to worry that the knock at the door will literally be Death. But they do on Spooner Street. Surprisingly, Death is actually rather shy, unable to talk to women, and pretty self-conscious. He also still lives with his mother, who smothers him. Death doesn't have the warmest personality, being rather sarcastic, blunt, and rude. Just don't touch him, or you'll end up dead as well!

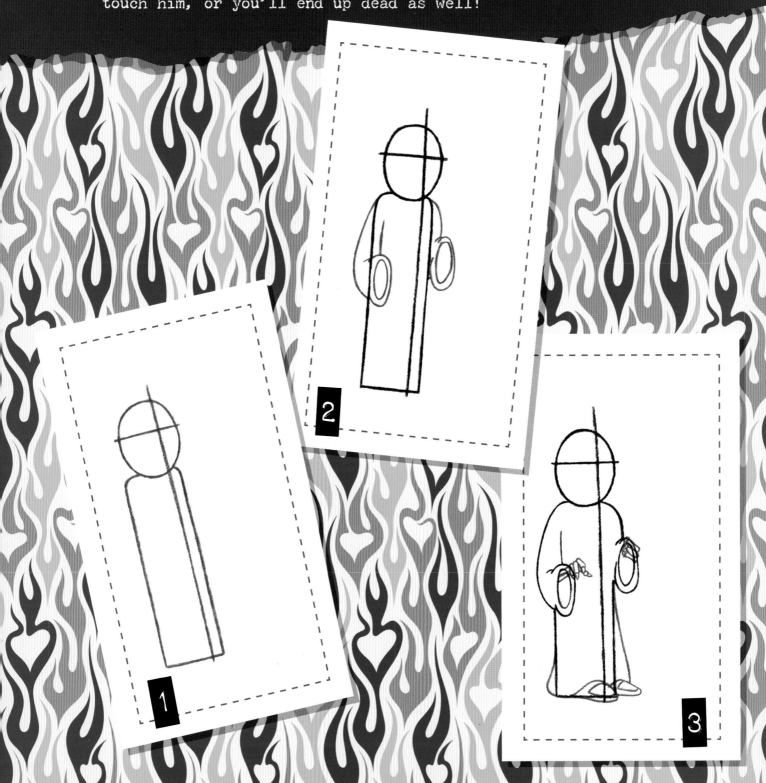

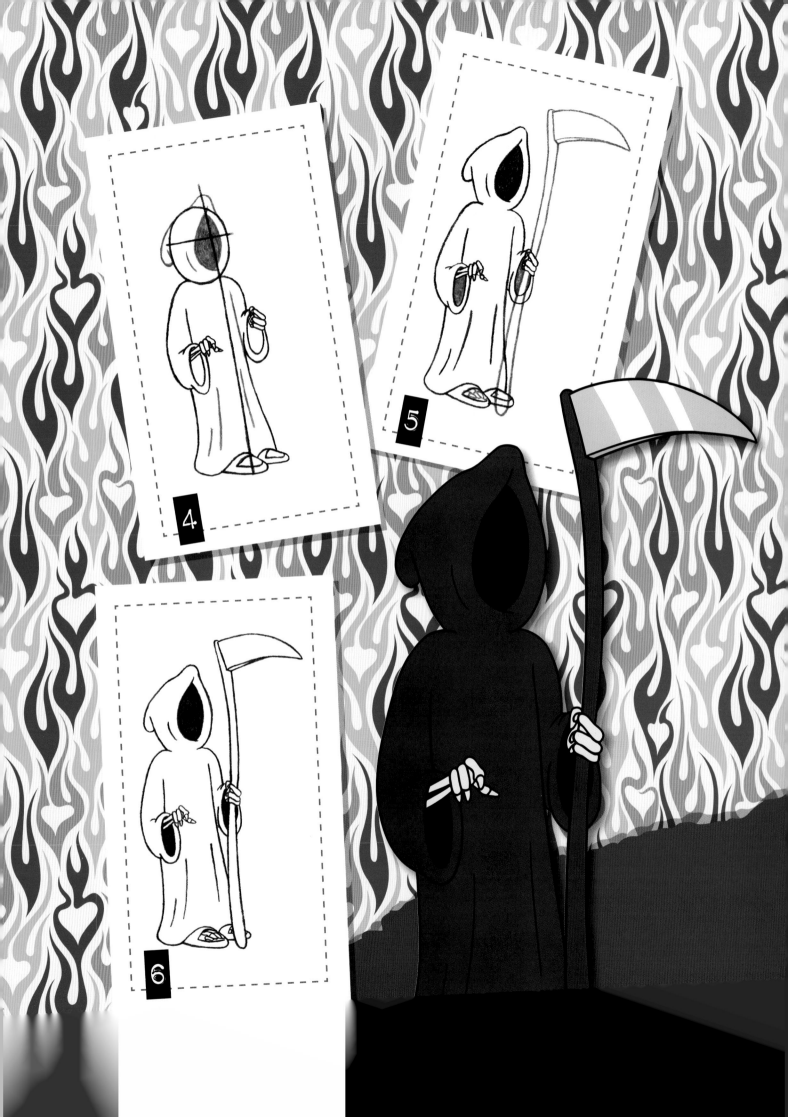

GLENN QUAGMIRE

Glenn Quagmire is the Griffins' next-door neighbor and Quahog's resident sex addict. He works as a pilot, but spends most of his free time seducing women at his bachelor pad. A confirmed foot-fetishist, Quagmire's trademark, "Giggity Giggity" is known to simultaneously arouse and repulse women all across New England.

1

2

3

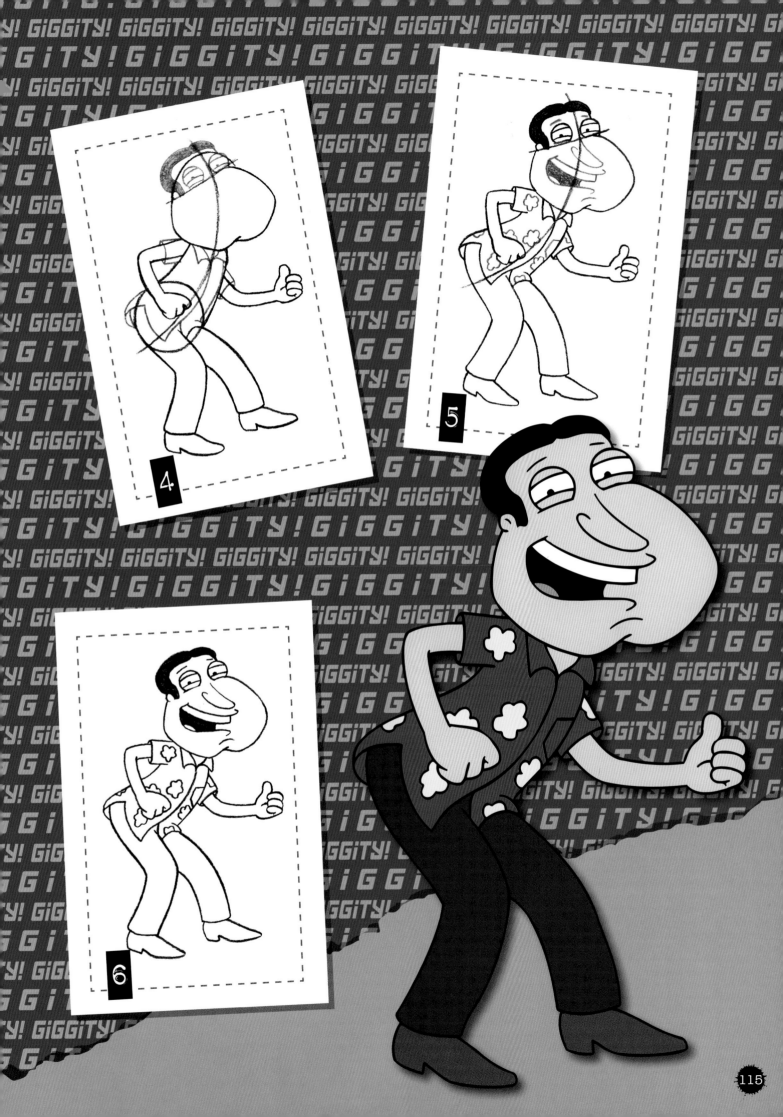

HERBERT

Herbert is a funny, very old, and very immobile man who lives on Spooner Street. Known for his special "interest" in Chris Griffin, Herbert is the perv of the neighborhood, but no one really panics, as he's pretty harmless.

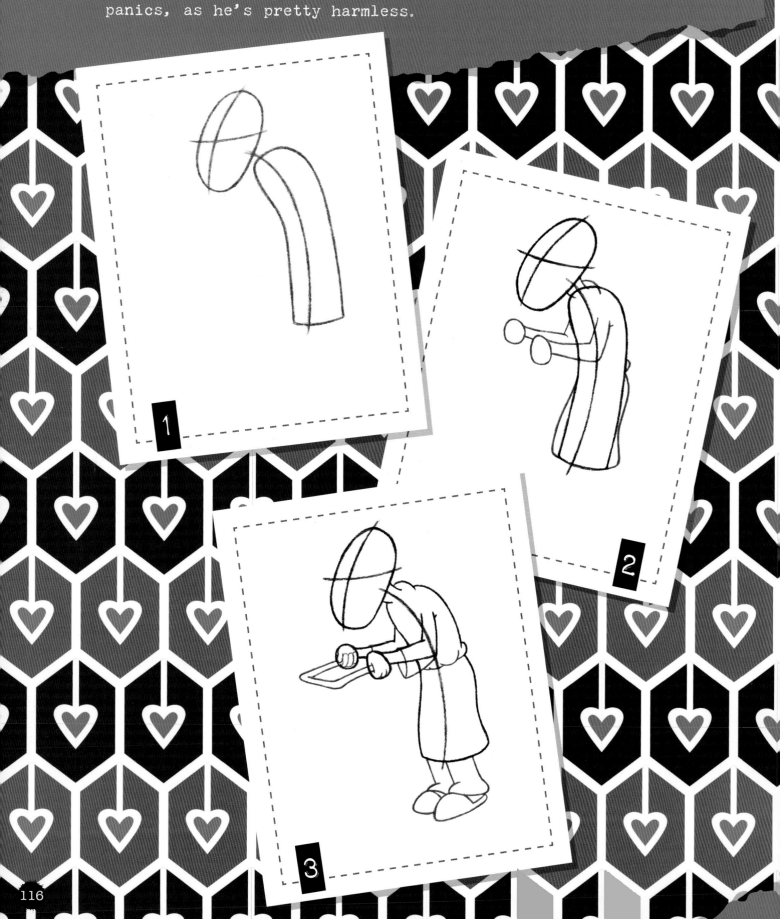

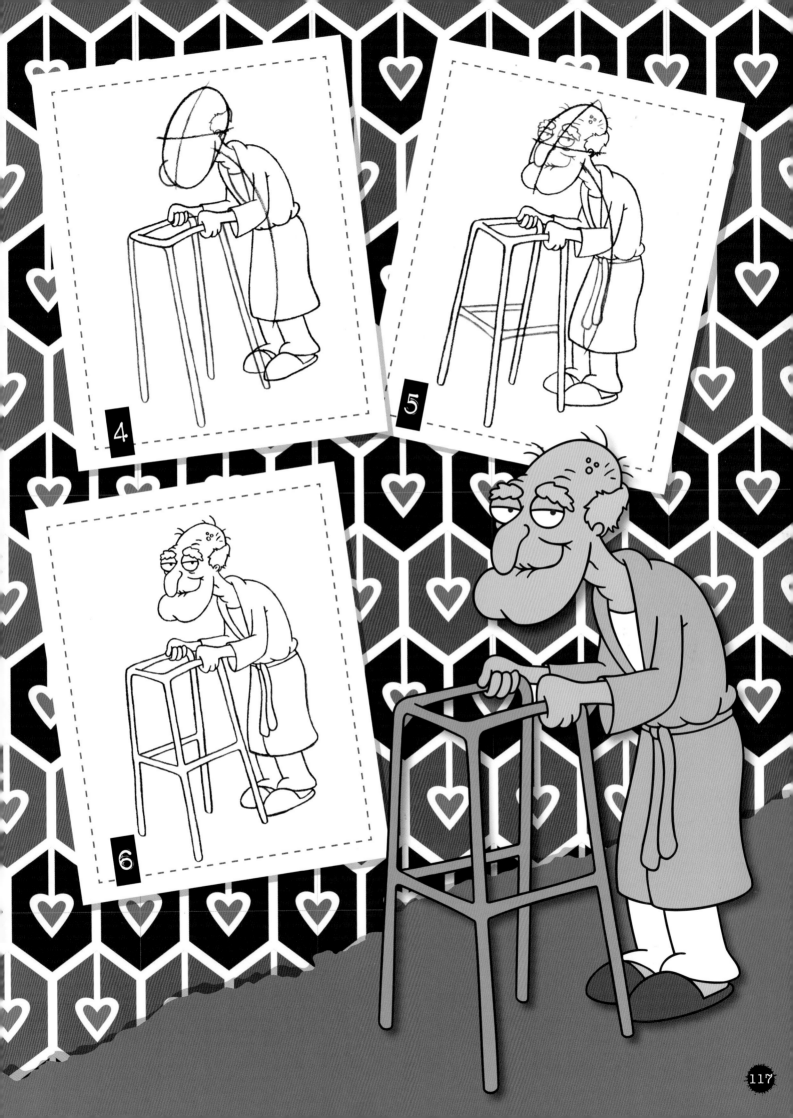

BRUCE THE PERFORMANCE ARTIST

Though Bruce is known as the performance artist, he has the distinction of filling just about every job imaginable. First seen as the clerk of a horror novelty shop, he's also taught a CPR course, been a member of the school-board committee, is a psychic, gives out the communion wafers at church, rents out shoes in a bowling alley, has been a boxing announcer, and was the nominal leader of an AA meeting.

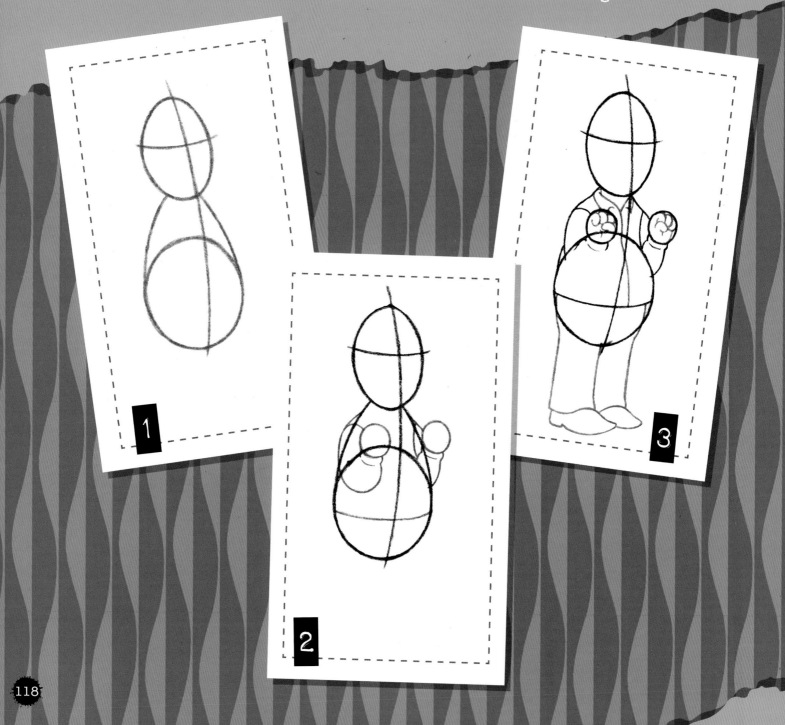

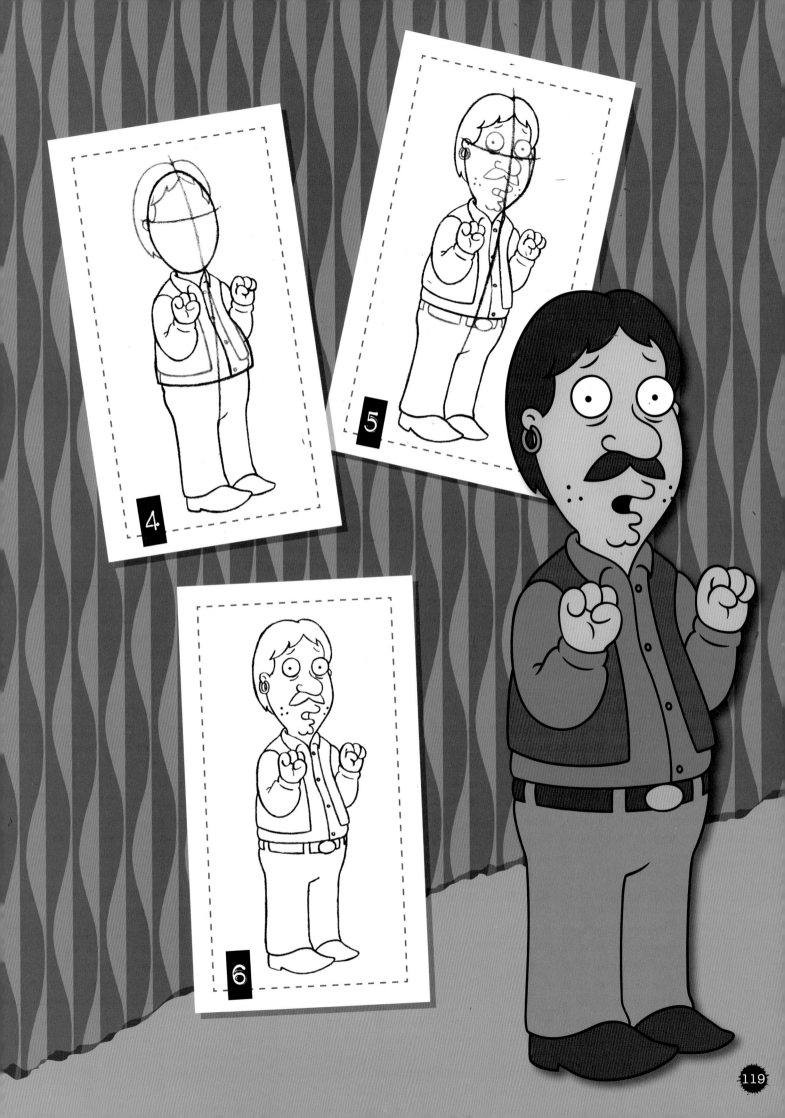

4

5

6

SEAMUS

You'd think it would be difficult to get around when you have two wooden legs, two wooden arms, and are blind in one eye—but sea captain Seamus seems to manage! The salty old dog is usually ready to warn Peter about all manner of danger, as well as apply for unexpected jobs, such as the church organist and a news reporter. His origins are shrouded in mystery—it was once suggested that so much of him is wooden because his father was a tree.

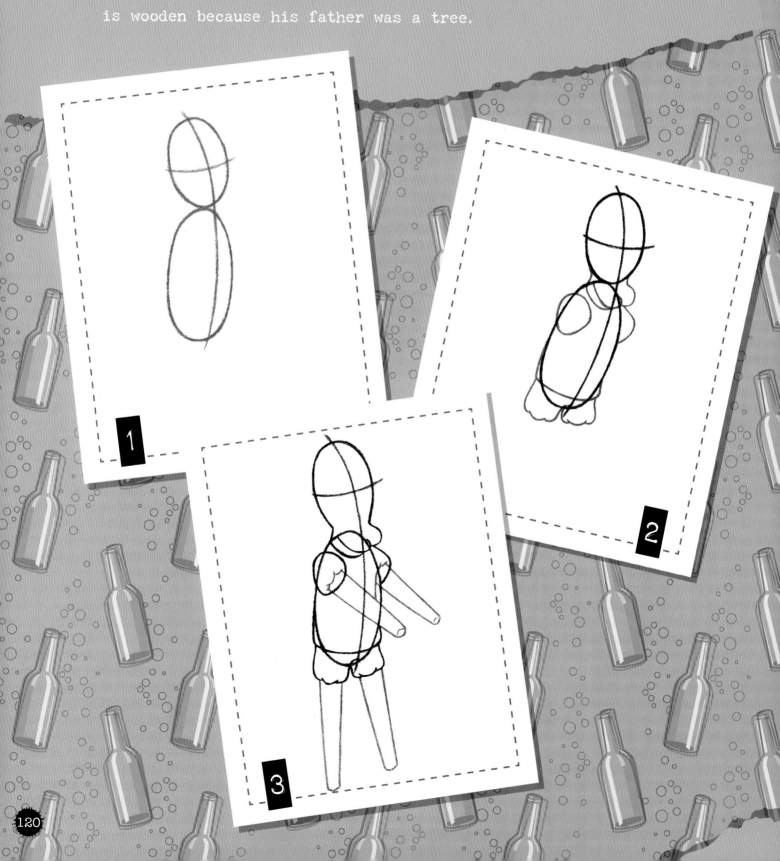

1

2

3

120

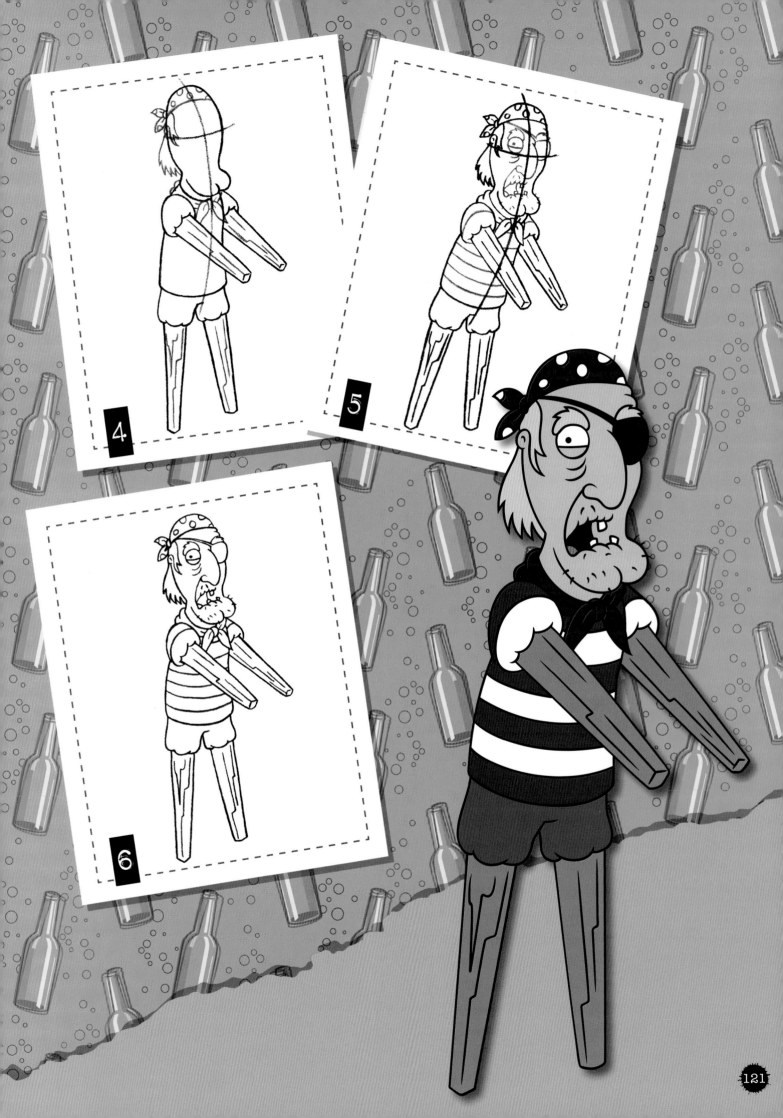

MORT GOLDMAN

Mort Goldman and his late wife, Muriel, shared strangely similar looks. Their gawky teenage son, Neil, is known for his obsession with Meg Griffin, who has absolutely no interest in him whatsoever. Mort runs the Goldman's Pharmacy. It's no surprise he went into health care, as Mort is a bit of a hypochondriac, slightly obsessed with his own bodily functions.

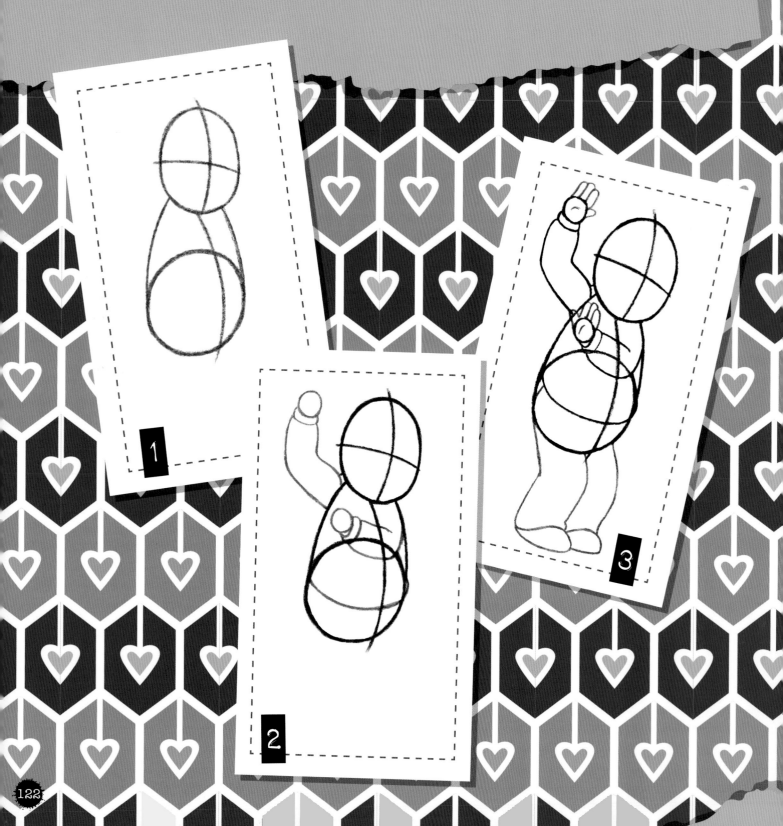

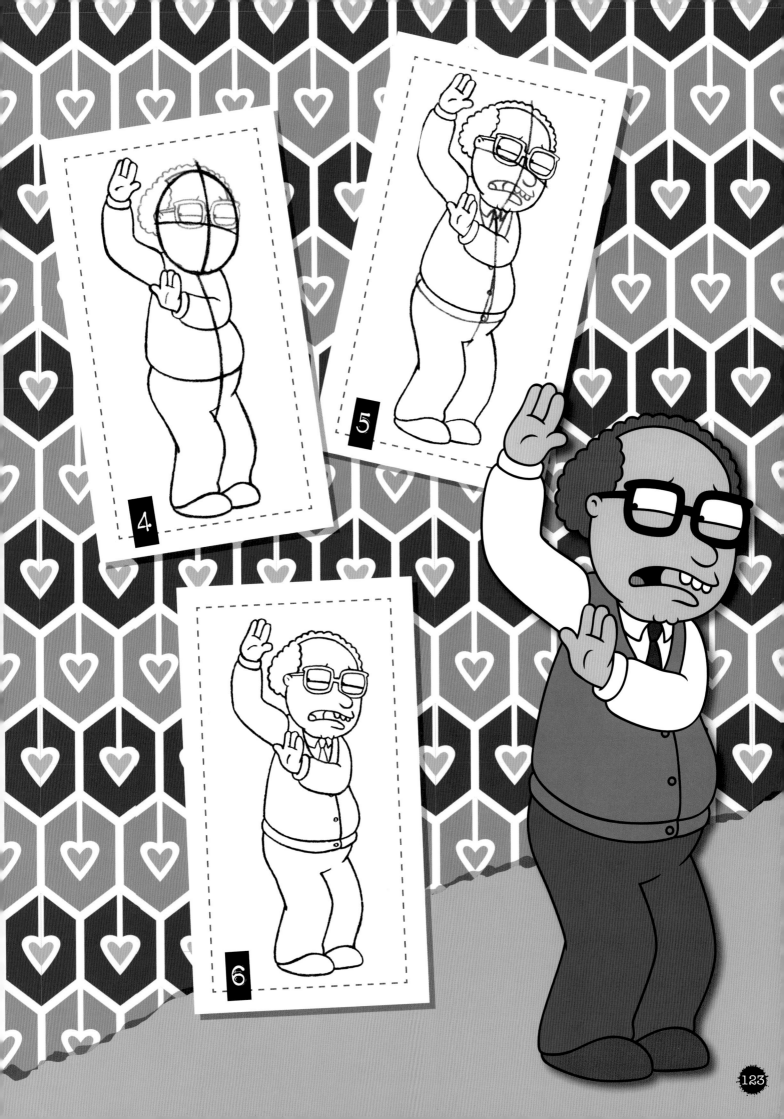

EVIL MONKEY

The Evil Monkey used to live in Chris's closet and, at unexpected moments, would open the door, point at Chris, and shake his arm with a sinister expression. Chris was the only member of the Griffin family aware of the Evil Monkey until he captured him in order to prove his existence to his parents. Upon capture, the Evil Monkey revealed that he points at people as an attempt to strike up conversation, and that his arm shakes because he suffers from copper deficiency. He explained that his sinister expression is actually his thinking face, and that he never intended to harm Chris. Although Chris didn't trust the Evil Monkey at first, the two have since developed a close relationship. The Evil Monkey, now known as just "Monkey," has moved on to Jake Tucker's closet.

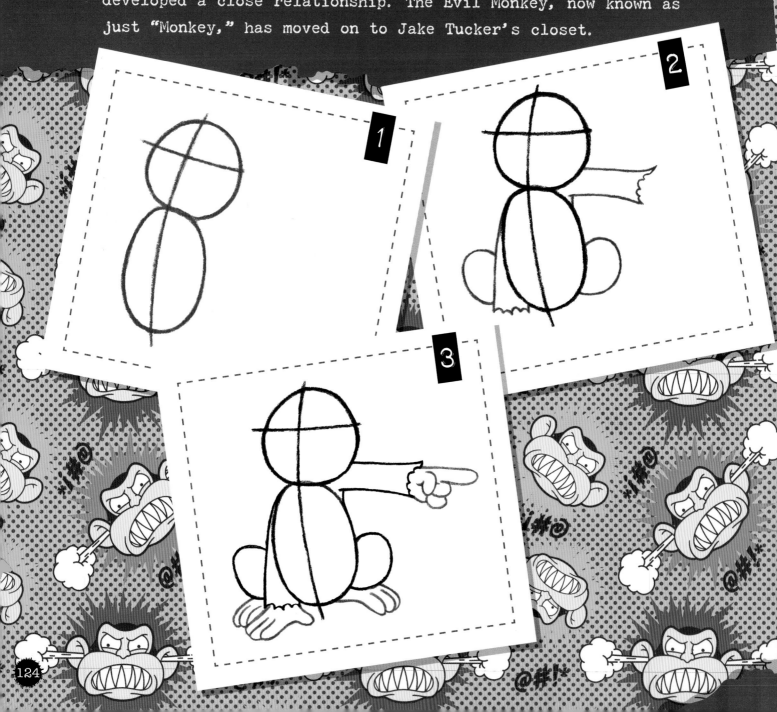

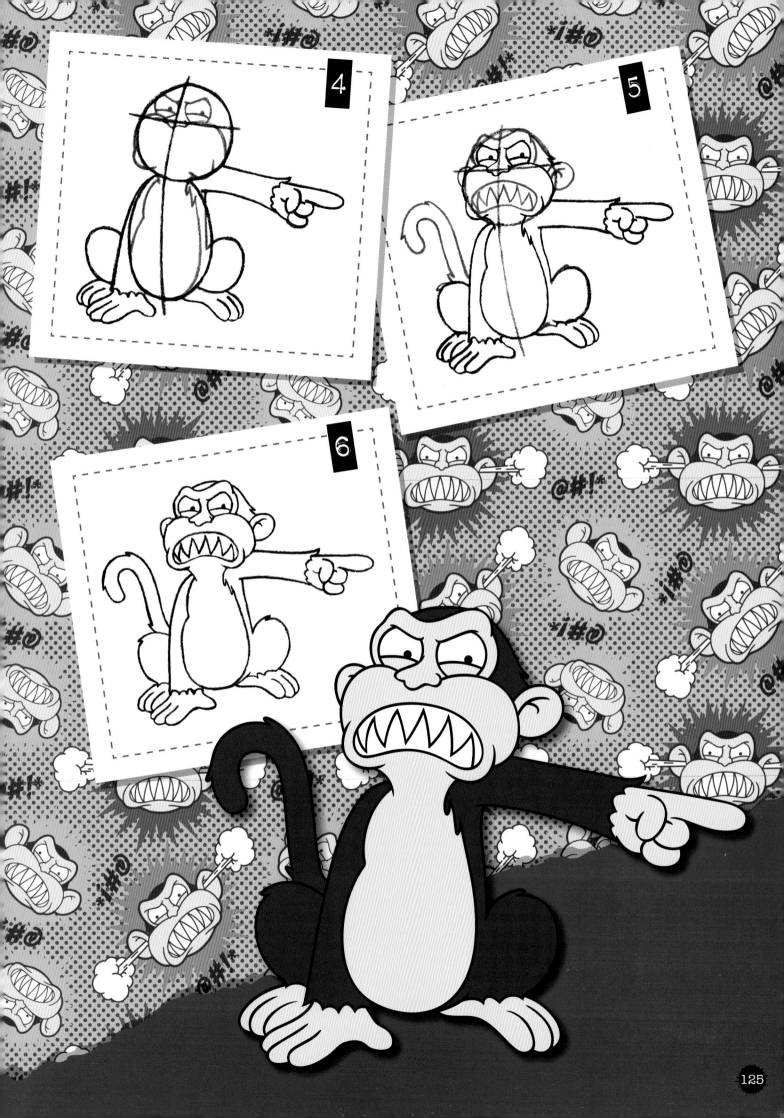

GOODBYE FROM SPOONER STREET

Test Your Knowledge Answers:

1. Jesse
2. Ida
3. Marguerite
4. A medical experiment he takes part in
5. Dingo and the Baby
6. Mickey McFinnigan
7. Peter
8. Quahog Mayor
9. Dr. Elmer Hartman
10. Petoria
11. The London Silly-Nannies
12. A TV channel Peter sets up after normal TV gets censored
13. El Dorado Cigarette Company
14. Fisherman
15. Pawtucket Patriot
16. Pearl Burton
17. Leg transplant
18. "Most Nickels Eaten"
19. Eating 30 hamburgers in a row
20. Doug
21. He gets addicted to cocaine
22. Morningwood Academy
23. A Mercedes car from a cargo ship that recently sank
24. Joan
25. Ann Lee Quagmire
26. He's an airline pilot
27. He hates being around his children
28. She was stuffed and turned into an end table
29. To avoid freshman hazing
30. "Death Has a Shadow"